C000062241

Lessons in Masterful
PORTRAIT DRAWING
A Classical Approach to Drawing the Head

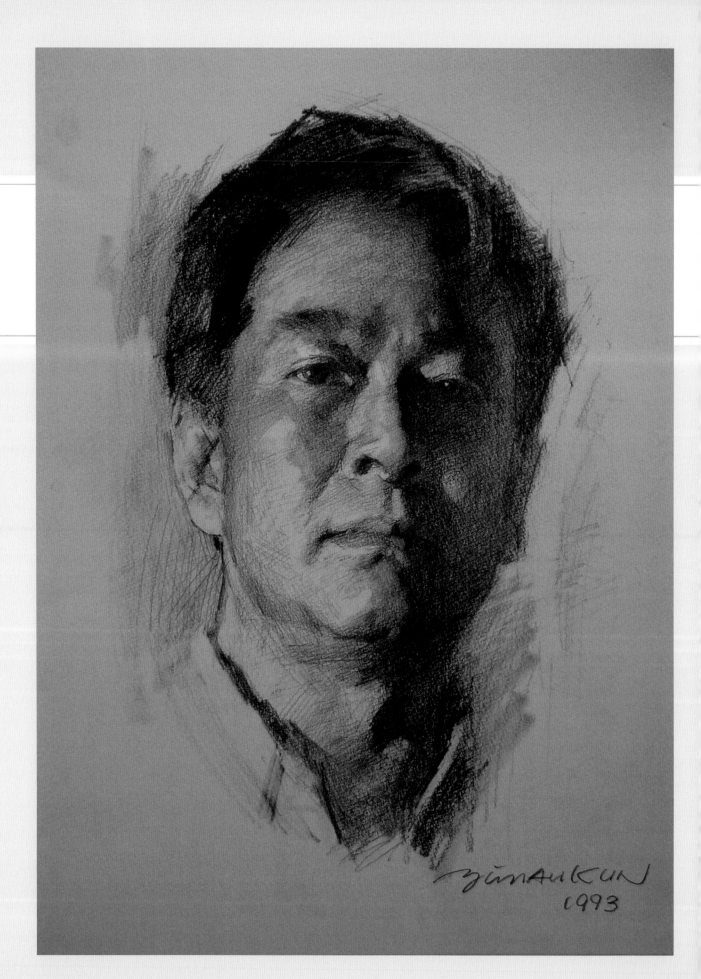

ZÜNAUKUN
1993

Lessons in Masterful

PORTRAIT DRAWING

A Classical Approach to Drawing the Head

MAU-KUN YIM & IRIS YIM

NORTH LIGHT BOOKS
CINCINNATI, OHIO
artistsnetwork.com

CONTENTS

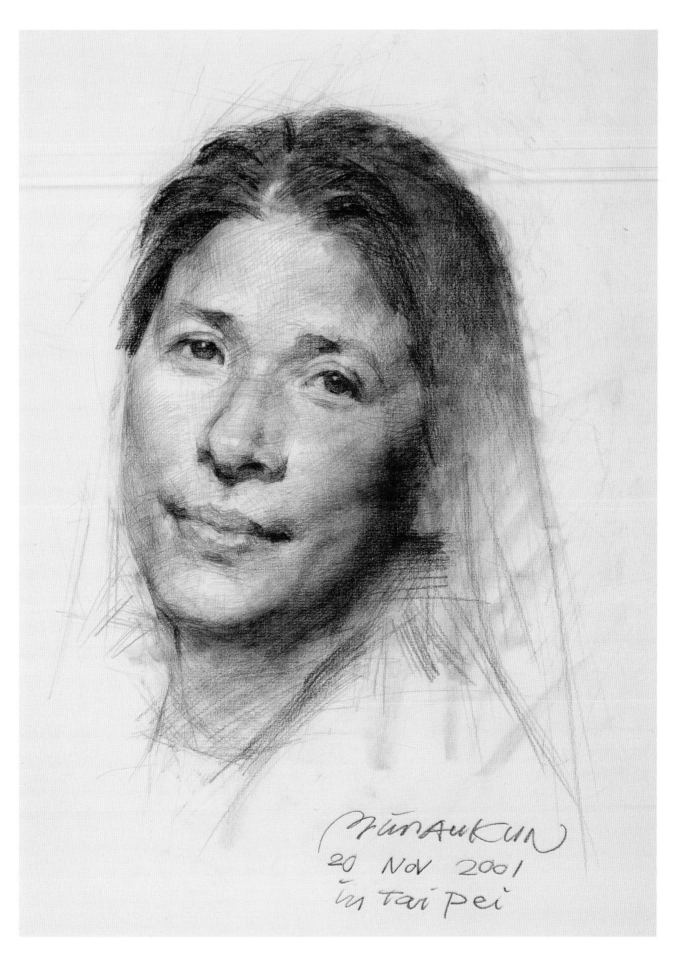

MINAMIKUN
20 NOV 2001
in Taipei

FOREWORD

IT'S ONLY RECENTLY that I have become aware of the artist Mau-Kun Yim. We have not met, yet I feel that I know the man. Through his numerous handsomely illustrated texts, he reveals himself to be a craftsman of surpassing ability and sensibility. The years of classical training and diligent study of the works of the masters that came before resonate in his virtuosity and boldness of handling. He is a dedicated and selfless teacher; he is a man in love with his calling.

We live in an age when frivolous fashion and hyperbole too often triumph over brains and talent; we must celebrate these few brave and vociferous champions of the great classical legacy who nourish and inform our venerable trade. It is to such rare men of character and high purpose that we must look for inspiration.

The keenly anticipated *Lessons in Masterful Portrait Drawing, A Classical Approach to Drawing the Head* will be welcomed by all practicing artists, students and lovers of fine drawing. The quality of this material—text and plates—is superlative. Such excellence is not negotiable and does not grow old. Treasures such as these will comfort us in those hours when fears and doubts come calling. We may then revisit these inspiring pages and be moved to try harder and reach higher in our own endless pursuit of excellence.

—*Ned Jacob*

XIANG MEI XIANG
Pencil on paper, 23¾" × 19½" (60cm × 50cm), 2014

6

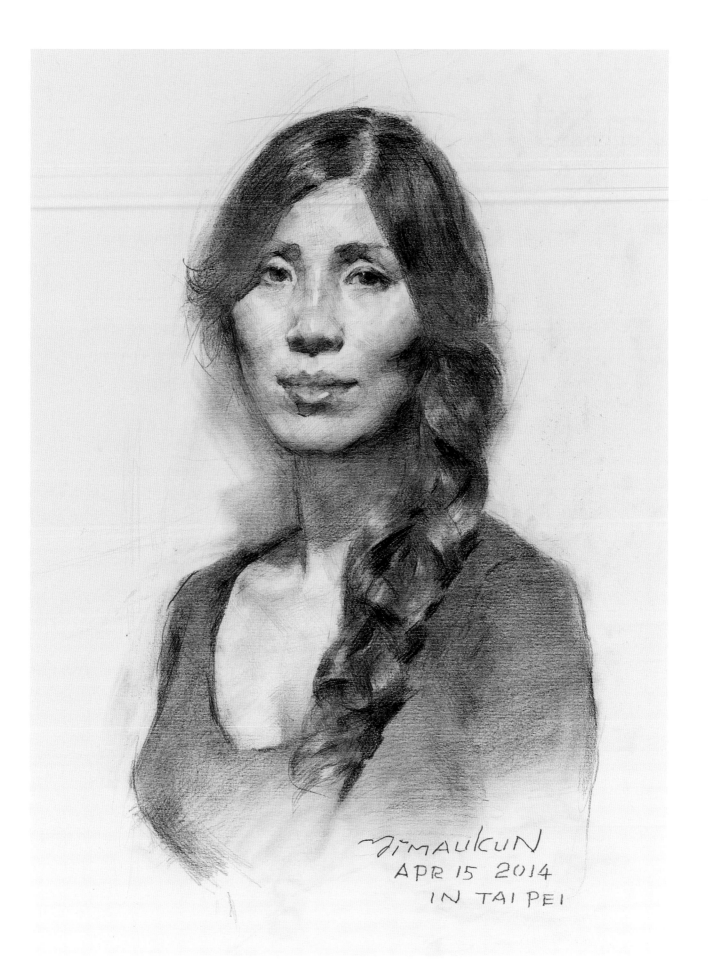

JimAukuN
APR 15 2014
IN TAI PEI

INTRODUCTION

I LOVE DRAWING. I'm quite proud of the sheer number of drawings I have produced, something that I attribute to the way I established myself in Hong Kong a long time ago. When I left China and arrived in Hong Kong in 1980, I was a stranger in a strange land with only the clothes on my back. In coming to Hong Kong, I was basically throwing away the career I had started in Guangdong, where my oil painting, *Soldier Song*, had won the first prize in a major art competition. I needed to start from scratch again with a clean slate. Through a series of accidents and coincidences, I opened a studio for private teaching in Hong Kong. Once I started teaching, there was no turning back. Since drawing is something that must be taught in the old master tradition, I ended up drawing for thirty years as well.

I must admit that I've been able to teach drawing for the last thirty years because I like it so much. When I teach drawing classes, I can't pass up on the opportunity to draw along with my students. That's why the model or still life that I set up for students is arranged the way I like.

A painter who doesn't like painting defies the imagination. A painter at work is just like a farmer tilling the field or a blacksmith striking the iron. So it is with me and drawing. You may call me an "artisan" if you like, but I agree with what Rodin once said: "If you are an artist then you can't possibly be anything else."

—*Mau-Kun Yim*

YOUNG WOMAN
Charcoal on drawing paper, 30¾" × 21¼" (78cm × 54cm), 2000

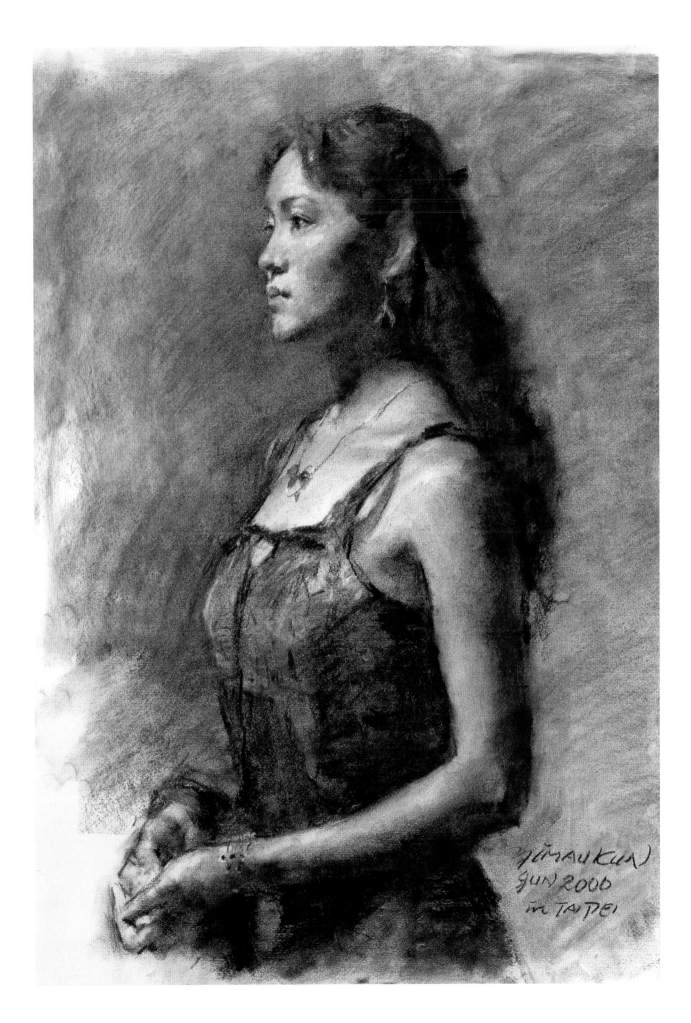

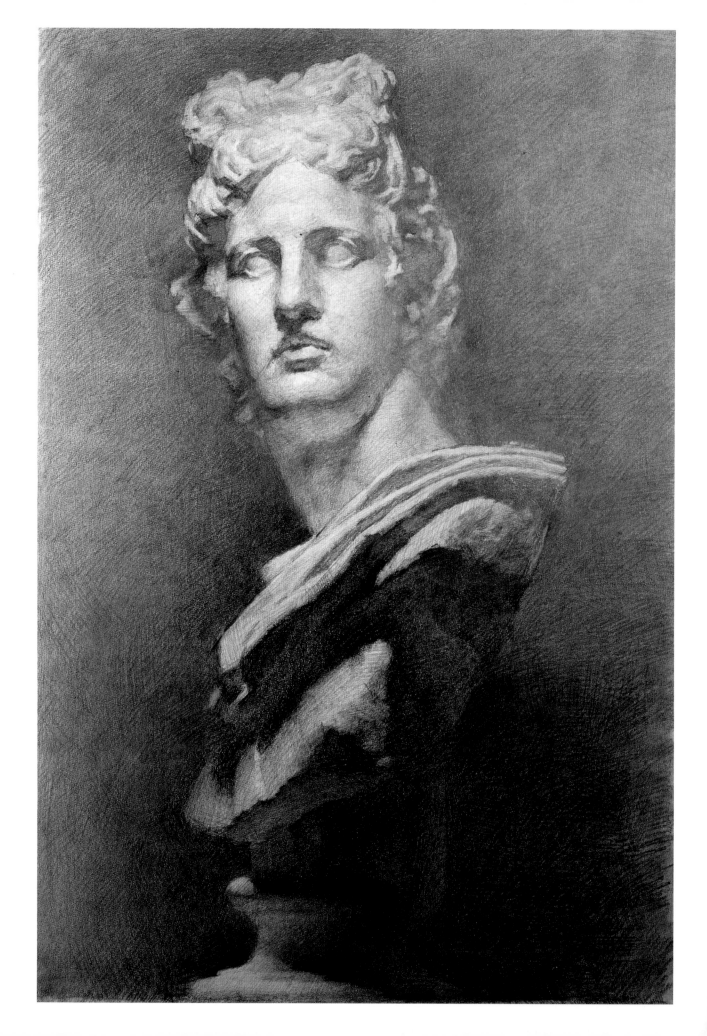

ABOUT DRAWING

IN THIS CHAPTER, I share my guiding principles and philosophy about drawing, which are based on my early training and decades of studio teaching and practicing. Understanding and practicing these principles will not only help you build a solid foundation for drawing but also create drawings that are a piece of fine art, not just a practice assignment. I also share in this chapter the importance of classical bust study sketching, which is an important way to train your observation and practice drawing skills before moving on to life portrait drawing.

APOLLO
Pencil on drawing paper, 25¼" × 17" (64cm × 43cm), 1999

FOUNDATION OF DRAWING

For me, the basics of drawing lie in classical bust study. When I passed the examination to enter the affiliated high school of the Guangazhou Fine Academy of Fine Arts in 1959, Liu Shaoqi had been put in charge of the central government after the economy had been crippled by the Great Leap Forward (a campaign of extreme economic policies and forced labor led by Mao Zedong). The extremism of political movements was reined in and the educational establishment began encouraging teachers and students to focus on basic skills and professional training. At our high school, these changes allowed the two classes in my year to follow through with our curriculum until we graduated four years later, which, because of the economic recession, was the exception rather than the rule.

Apart from watercolor and art creation, our classes also involved a great deal of classical bust study. Many people have commented on the number of outstanding Chinese realist artists produced during this period of time. Teachers and students ask me what made our class so special. In my opinion, it was because these two classes were spared the so-called "educational reforms" that came along with the Cultural Revolution that began in 1966. Instead, we did a lot of pastel cast drawing and built a really solid foundation that we were later able to apply to drawing real people.

Since the Renaissance, plaster cast drawing has been the most important training exercise in studios and art academies because it includes proportion, perspective, volume and value. The clean, white appearance of classical busts makes it easier to study the relationship between light and form.

Based on my experiences, I eventually concluded that classical bust study is the most essential of the basics of drawing.

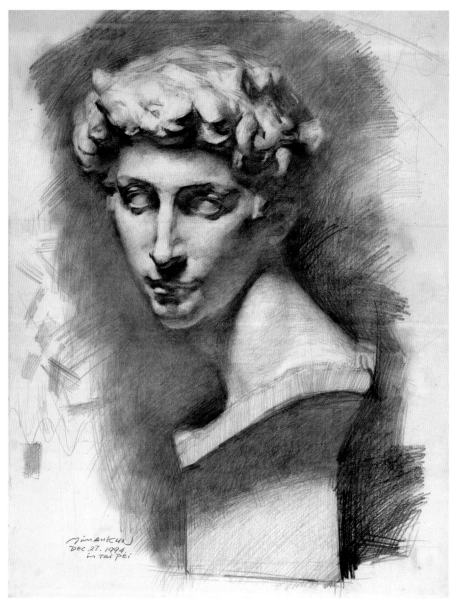

GIOVANNI MEDICI
Pencil on drawing paper, 23¼" × 18½" (59cm × 47cm), 1994

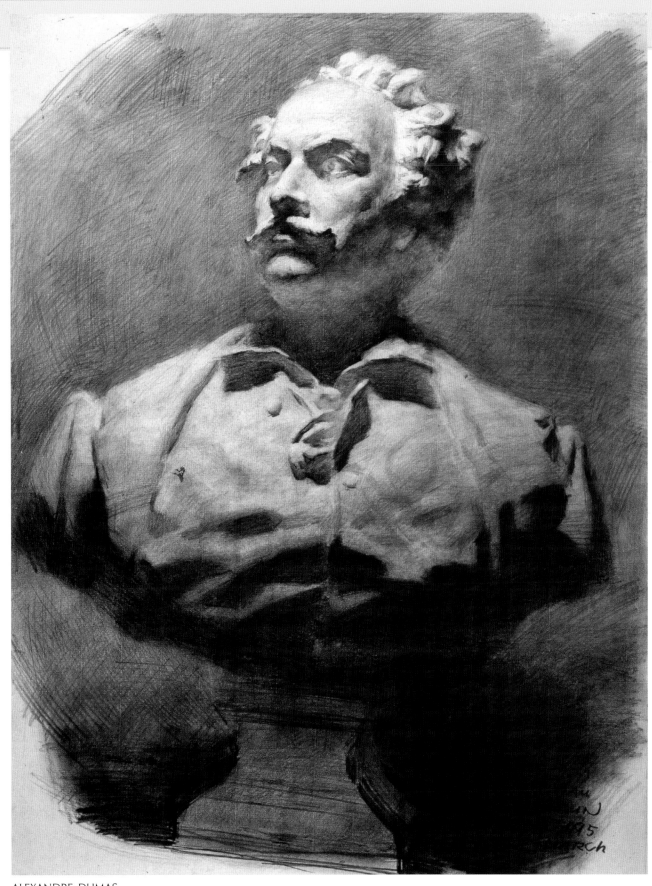

ALEXANDRE DUMAS
Pencil on paper, 25½" × 19½" (65cm × 50cm), 1995

DRAWING IS PAINTING WITHOUT COLOR

Drawing is a skill that needs to be trained. It requires critical thinking and rendering. The core of drawing is exploring and rendering the essence of life—seeing beyond colors to reveal an intrinsic artistic form. Since there is no color in a drawing, it avails the artist the opportunity to translate what he sees in color into colorless lines, value and strokes. This is the most pure and intrinsic art form.

Although color is missing from a drawing, the art of drawing covers all other elements of painting, including proportion, volume, perspective, space and texture, and therefore provides a foundation for all forms of painting. Most problems that occur in a painting are due to poor drawing skills. If these basic drawing skills are not well developed, the image in a painting will crumble like a building upon a poor foundation.

Drawing is a process—the process of building a subject on paper, the process of observing, exploring, thinking critically and depicting over and over again. It gives one endless challenges to overcome, but in the end, success will bring infinite joy. When diving deep into the world of drawing, you will gain confidence from reflection and self-improvement. It's a very rewarding experience.

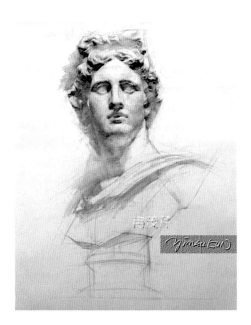

Drawing is also a means of engaging in a dialogue with life. When we acquire a deep understanding of the characteristics of life—and depict and seek out the shape and features of this life—the vitality of the object appears vividly on the paper. Although a drawing portrays its object using only lines and layers of black and white, its ultimate objective is to create a vivid and credible artistic rendering.

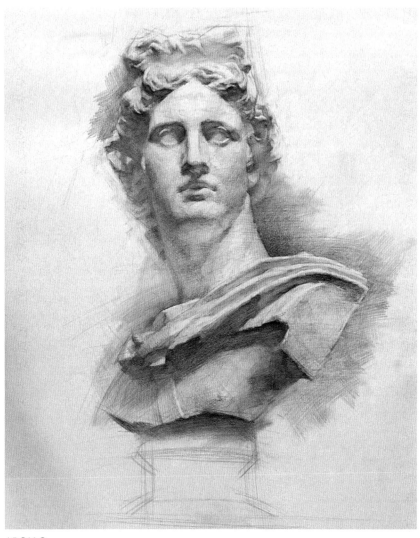

APOLLO
Pencil on drawing paper, 23¼" × 18½" (59cm × 47cm), 2003

DRAWING IS A FORM OF CONSTRUCTION

Drawing is a form of construction on a two-dimensional plane. Here the word "construction" refers to building something in the same way architects and sculptors do.

We are accustomed to thinking of drawing or painting as a form of portrayal of a subject that doesn't imply a sculpting of physical volume. Five hundred years ago an interesting debate occurred in Italy between Leonardo Da Vinci and Michelangelo on the relative merits of painting and sculpting. However, the argument between the two great masters of the Renaissance is still unsettled. In sculpting, a physical volume is recreated in physical form. In painting and drawing, the "physical volume" is recreated on a plane.

Though the physical volume on a plane is a virtual construct, the painter can use the space around the object to depict any historical scene or imaginary setting. That is why the masters of the Renaissance used proportions, perspective, value, anatomy and aerial perspective to help build an illusion of three-dimensional objects on a two-dimensional space. From these efforts emerged great artworks such as the *Last Supper*, *Mona Lisa*, *Sistine Madonna* and *Academy Athens*. The paintings were the two-dimensional equivalents of architectural masterpieces like the St. Paul Cathedral and Notre Dame in Paris in terms of sophistication and artistic merit.

As we approached the contemporary era, people started tearing down the walls, doors and windows of those grand buildings and left them lying around on the ground. Today, reconstructing shapes and volumes on paper has somehow become extremely difficult. We must rediscover the principles of proportions, perspective, anatomy, value, light, shadow and surfaces in order to rebuild the architecture of two-dimensional art in both drawing and painting.

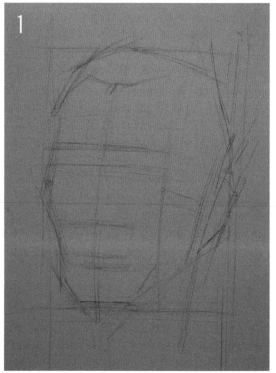

Blueprint
Define location and boundaries

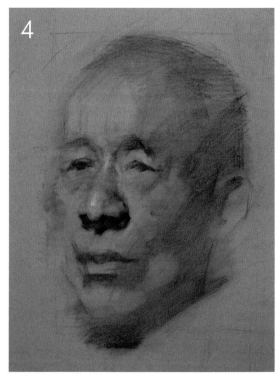

Wiring, plumbing and drywall
Add details

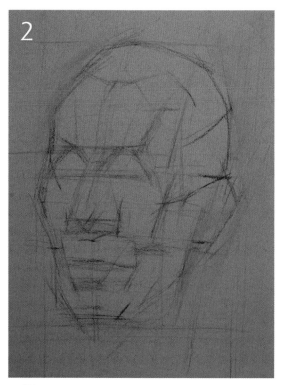

Foundation
Block in with straight lines

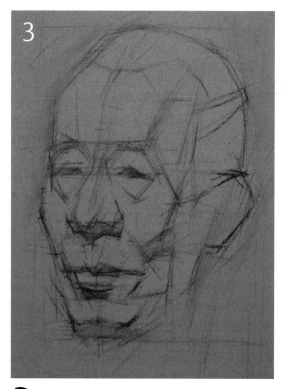

Framing and roofing
Conduct planar analysis and add value

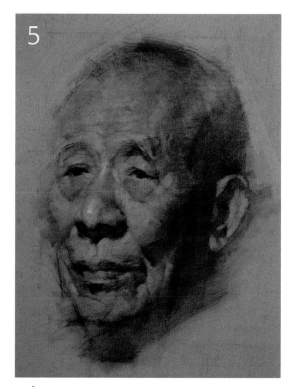

Utilities and finishing
Refine, re-examine and finish

CONCEPTS OF STRUCTURE

A good drawing starts with solid understanding of the structure of the subject. There are three concepts of structure:

1. *Geometric structure.* Examples include the cubes, spheres, rectangles and cylinders that define the human form. Unless we can observe and comprehend these shapes in a systematic manner, our drawings will feel haphazard and disjointed.

2. *Internal structure.* This usually refers to the skeleton and muscles underneath the skin. The form of the skin is determined by this underlying structure. A lack of knowledge about the internal structures leads to shallow and amateurish results.

3. *Surface structure.* The surface structure is defined by the contours of the skin as it appears to our eyes under certain lighting conditions. The contours are very subtle yet filled with texture, color, life and feeling. They determine the ultimate worth of the work. I've seen far too many cases where an artist got the proportions and anatomy right, but the drawing still came across as flat and lifeless. The artist invariably ignored the sensual nature of the subject under the lighting of that particular time and space.

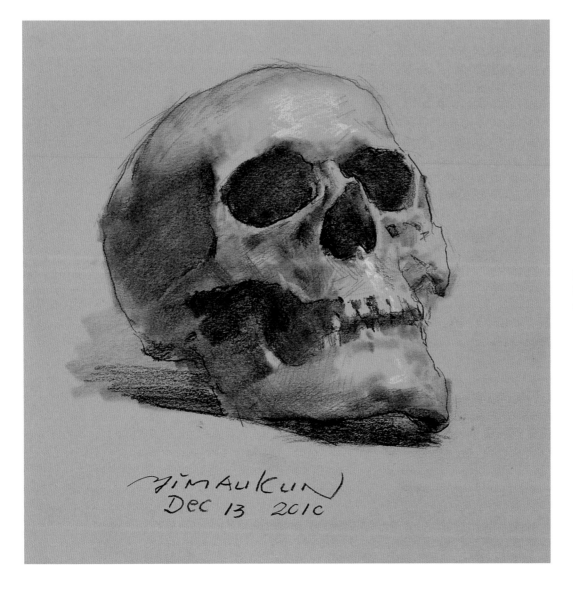

SKULL
Charcoal pencil on
drawing paper

OBSERVE THE WHOLENESS

Soviet artist Konstantin Maksimov advocated the wholeness observation and wholeness presentation principles. What does that mean? My interpretation of the concept is to start with large blocks, straight lines and masses of light and shadow before gradually moving on to the features, details and expression in a drawing. If you can get the relationship between the building blocks right, then a harmonious whole will emerge. If you can master the concept of the whole, then you might become a great artist. If you don't, then a craftsman is the most you will ever be.

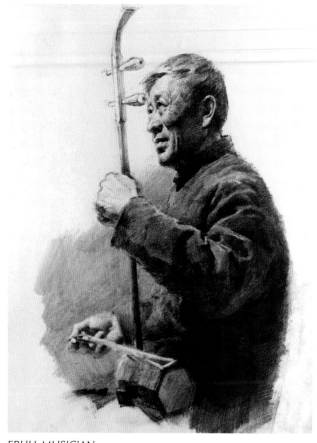

ERHU MUSICIAN
Pencil on drawing paper, 25½" × 19½" (65cm × 50cm), 2000

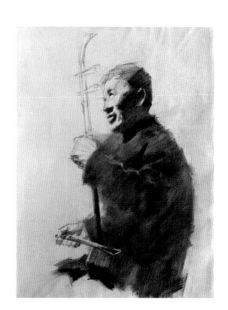

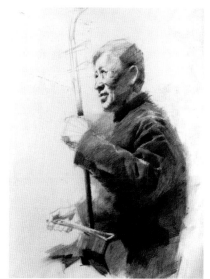

The midtones are an important element in the value scale when drawing light and shadow. It is the midtones that give depth, variety, realism and interest to objects and images. Our eyes are required to appreciate the finer rhythms of the midtones, which makes them all the more sensual. When compared to pure black and white, don't the midtones come across as more musical? For the artist, the exquisite variations make midtones all the more challenging yet compelling.

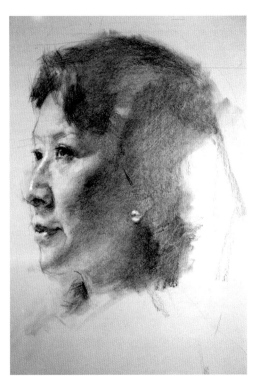

WOMAN WITH
LONG HAIR
Charcoal pencil on drawing
paper, 19" × 13½" (48cm
× 34cm), 2002

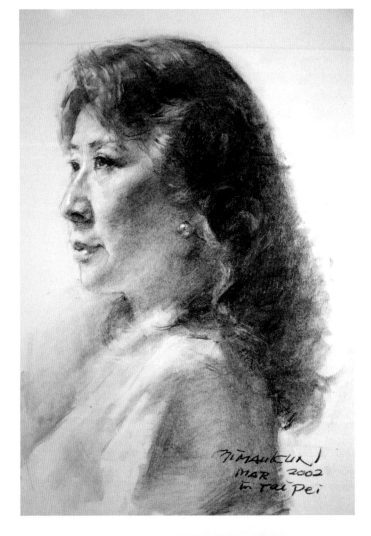

DEPICT THE STATE OF MIND

In criticism and interpretation, the early twentieth-century scholar Wang Guowei said, "The state (*jingjie*) does not just mean a certain place or object. Happiness, anger, sorrow and joy are also a state of the human mind. Those that capture the essence of the scenery and emotions can be said to have lived up to the ideal of realism; those who don't do not." This ideal is what every drawing should strive for. It defines the ultimate value of an artwork. It is not enough for a drawing to look right and have good likeness. It needs to be interesting, touching and evocative in order to become a true work of genius.

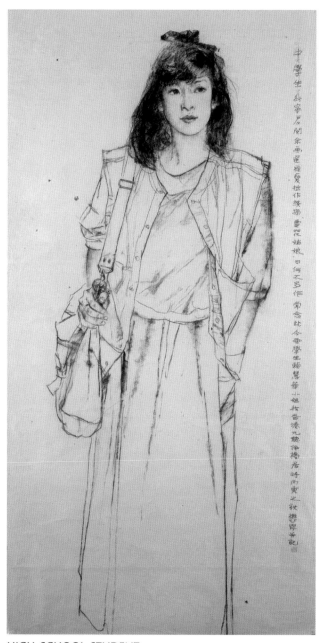

HIGH SCHOOL STUDENT
Charcoal on rice paper, 52½" × 26½" (133cm × 67cm), 1986

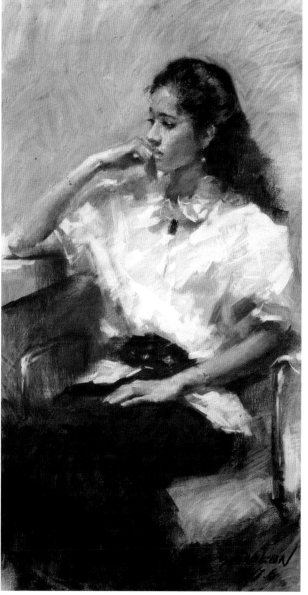

LADY IN WHITE
Charcoal on canvas, 39½" × 21¼" (100cm × 54cm), 1987

DRAWING FROM LIFE

The hallmark of realism is drawing and painting from life. Every life-drawing session is a new journey of exploration into life and art. We must approach life with sincerity and respect. In order to experience the joy of discovering the dignity of life, we must abandon our self-consciousness and self-awareness. We must also respect the subject. Do not "improve" the subject without a good reason or trample over the subject by imposing your so-called personal style upon it.

After carefully observing the subject, you must also maintain your distance from reality in order to find an image inspired by life. Before putting pencil to paper, let the image take shape in your mind. Now use all of your skills and experience to pin down that image and let your thought guide the pencil.

In Western art, life drawing puts the object in front of the artist, so a lot of people think it is enough to just reproduce what is seen. This is a serious misconception that frequently leads to stilted and lifeless drawings bogged down in details.

You must not only draw from life but also aim for a "higher purpose" for your drawing . A century ago, the great Russian theater director Constantin Stanislavski told actors that their "higher purpose" was to breathe life into their characters. The same can be said of the portrait or figurative artist.

Nice, France, 1994

A good drawing needs to resemble the subject both faithfully and aesthetically. If a realist artist can't make a faithful likeness, then the artist doesn't live up to the name of being a realist. However, in terms of likeness, you don't want your work to look like a photograph that lacks rhythm and variation. A drawing too lifelike indicates a lack of judgment and prioritization in the representation and also a lack of aesthetics. To be faithful to the subject artistically is to prioritize and be selective in one's approach.

There is one thing in common between Western art and Chinese art. It's called the ink brushstroke in Chinese painting and paint brushstroke in Western painting. Brushstrokes (as well as pencil strokes) make a painting artistic and not identical to the subject.

The artist is not just drawing the subject without thinking. Instead, he or she draws the details of the subject selectively, based on judgment. Details and depth are relative. Rendering details is a further exploration and studying of the subject, identifying interesting characteristics and elements. Rendering details is not recording every single detail like a camera; it includes addition, subtraction and rearrangement.

There is no single way to render details. You should follow your feelings about the subject.

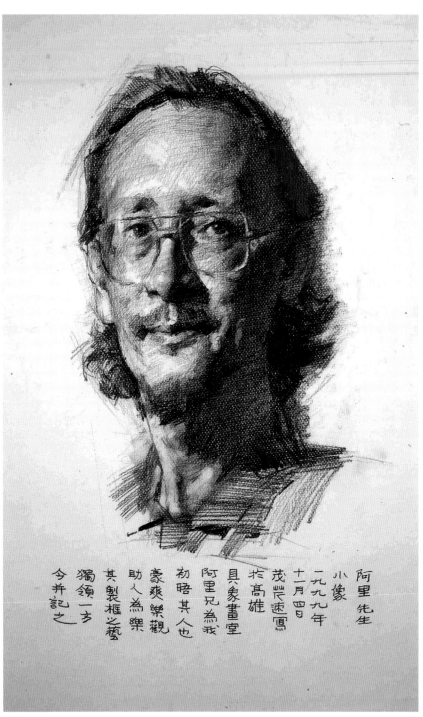

A LI
Pencil on drawing paper, 15¾" × 12½" (40cm × 32cm), 1999

THE IMPORTANCE OF A HEAD PORTRAIT

Drawing a head portrait is a very important skill in figurative drawing. The head is the most important part in a full portrait. An artist can use head portrait skills to create characters with vivid facial expressions conveying emotions in a narrative drawing. In addition, head portrait skills are practical for drawing friends and family in daily life. To draw a good head portrait is the most fundamental practice in figurative drawings.

VETERAN
Pencil on drawing paper, 15¾" × 13½" (40cm × 34cm), 2000

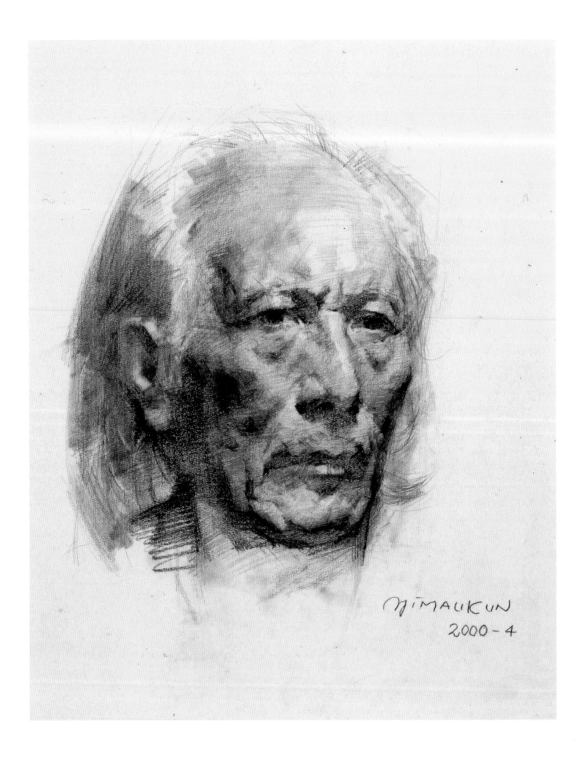

WHAT IS A GOOD PORTRAIT?

When you draw a head portrait you need to capture both form and spirit to make it a good drawing. The form refers to the external appearance of the facial expression and the person's position. Spirit refers to the disposition of personality and energy. In a head portrait, form and spirit are two indispensable, inseparable elements. The form contains the spirit. The spirit is the soul of the form. They are interdependent.

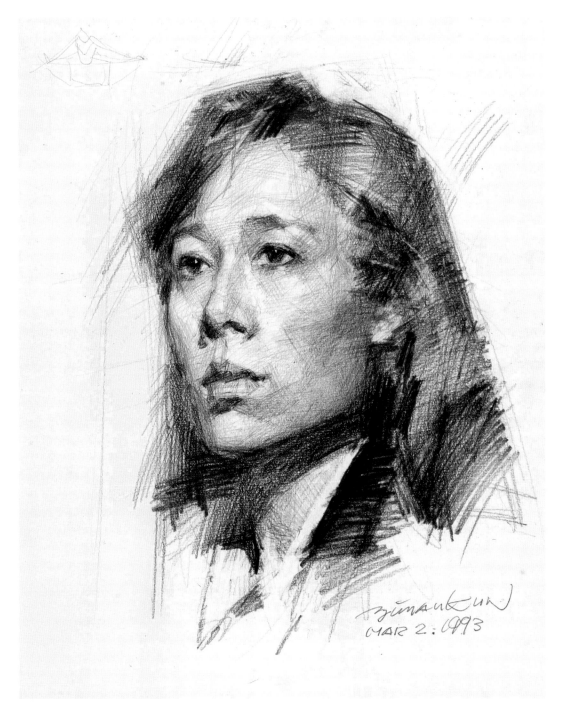

TAIPEI WOMAN
Pencil on drawing paper, 17¾" × 14½" (45cm × 37cm), 1993

CREATING A PORTRAIT WITH FORM AND SPIRIT

Pay close attention to the form of the subject, study the skull and observe closely the facial features. Spirit and mood can be captured in a few places. Take the corners of the mouth, for example, the eyes, eyebrows, nostrils and nose. The bridge of the nose is fixed, but the nostrils will move because of muscle movement. The mouth moves quite a bit. So do the eyebrows. Over the years, habitual facial movements will create a person's unique look. So we need to capture the parts through which we can represent the subject's unique look.

Correctly capturing characteristics of the form comes from observation and experience. When working on facial features, first establish the nose on the correct position, you can then benchmark the eyes and mouth against the nose. Another way is to capture the distance between the facial features. As a rule of thumb, the distance between the hair line and the eyebrows, from the eyebrows to the tip of the nose and from the tip of the nose to the chin is about one-third of the length between the hair line and the chin respectively. This of course varies slightly from person to person.

In addition to capturing the characteristics of the form, we need to attempt to understand the personality and mood and capture the spirit of the model so we can go beyond a photo to convey the spirit in an art form. In order to capture the spirit, first pay attention to the eyes. Observe how the eyes move. Then pay attention to the eyebrows and the corners of the mouth. The sitter's pose, such as positioning of the head and the arms, is also a reflection of the inner state. If appropriate, you may attempt to have a conversation with the sitter to get a sense of his or her personality.

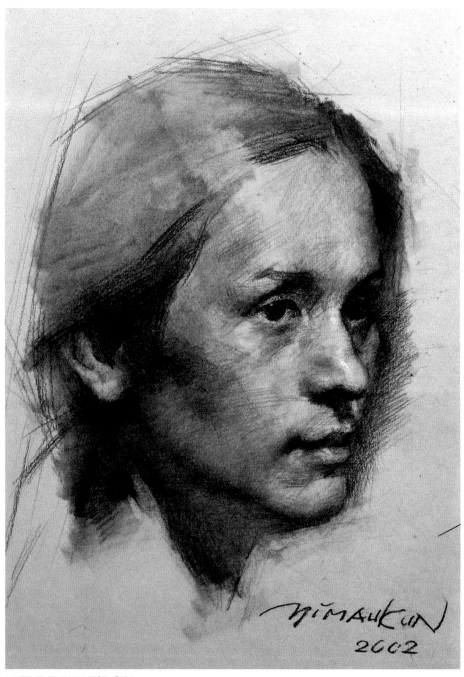

NATIVE TAIWANESE GIRL
Pencil on drawing paper, 17¾" × 14½" (45cm × 37cm), 1993

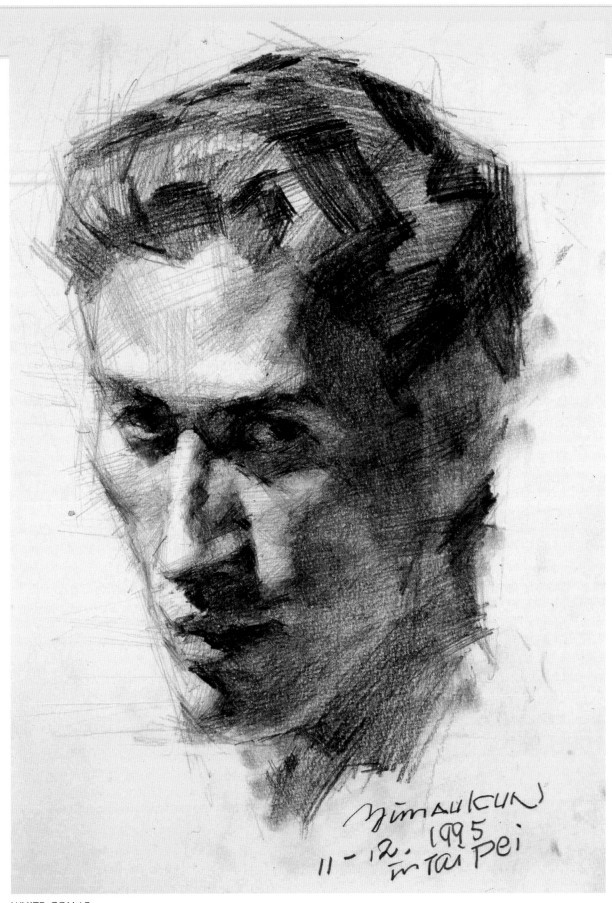

WHITE COLLAR
Pencil on drawing paper, 13" × 9½" (33cm × 24cm), 1995

SKETCHING

A good portrait drawing comes from keen observation of the subject's appearance and spirit and capturing that observation on paper. An important way to train observation skills is sketching—sketching people and surroundings in your daily life and when you travel.

WHAT IS A SKETCH?

Semantics suggest that sketching refers to drawings done quickly. But how quickly is quick, and how slowly is slow? The definitions can be hazy and not black and white. Is sketching all about lines, and it becomes drawing if you add shading? Does adding in the background and a theme disqualify it as a sketch? Sketching is not easy to define and can't be quantified in terms of time. In my own experience, live drawings that do not take more than one hour can be considered sketching. Basically, all sketches share one common characteristic: conciseness.

Nowadays, artists rarely create representational studio drawings that tell a story. Even if they do, it is pieced together from photos. The result naturally comes across as stiff and unimaginative. Many people don't even know how to create narrative paintings from modern society, so historical paintings are naturally beyond their skill. There are many reasons for this. Apart from there being a lack of understanding of the theory, they don't know how to conduct research, come up with compositions, or create studies prior to starting the painting. At the root of it all is a lack of training in sketching.

People who don't know how to sketch usually have problems creating studies for larger pieces. People who are good at sketching do not have this problem. Sketching allows ideas to be explored through drafts and small drawings without falling into the habit of relying on photos.

Sketching also trains our reflexes and judgment; it hones the observation of the eyes and drawing skills of the hand as well.

SKETCH OFTEN

All skills follow the convention that "practice makes perfection." Without practice, how can you become good at something? Diligence and training may be old school, but that doesn't mean they do not work.

In the Chinese opera community, they often say, "Martial arts must be practiced constantly and songs must be sung frequently." Diligent practice is therefore the key. What about diligent practice without giving it proper thought? That does not work either. As Confucius once said, "Knowledge without thought leads to confusion; thought without knowledge leads to danger." Some people have drawn for their whole lives and made many drawings, so they are definitely diligent. No thought went into those drawings, however. Confucius also reminded us that, "The role of the heart is to think." The brain is made for thinking! If we are curious and respectful of the lives that we try to capture, if we can then practice diligently and think constantly about improvements, we will naturally get better!

SKETCH SLOWLY

Is faster better in sketching? Not always! I've seen many private studios in the West, Hong Kong and Taiwan where the time allowed for nude sketches is so short that the paintings come out looking like wild scrawls. Many people spend years sketching in studios and make no progress whatsoever. Because they made no improvement, they decided that they simply didn't have the talent. Talent may, of course, be a factor, but I think that in most cases they were going too fast. I have heard that nine of ten accidents are due to speeding, so my advice is: If you want to sketch well, sketch slowly.

First, try to get the proportions right, capture the key features and make everything as simple as possible. Slowing down will help you avoid misshapen proportions and too

SELF PORTRAIT (at right)
Pencil on drawing paper, 12" × 11" (30cm × 28cm), 1985

In 1985 I opened a personal studio in Hong Kong to teach painting. Three years later, I hosted my first solo exhibition at the Hong Kong Arts Centre and published *Selected Paintings of Yim Mau-Kun*. This is one of the pencil self-portraits I drew for the inside cover of the exhibition program.

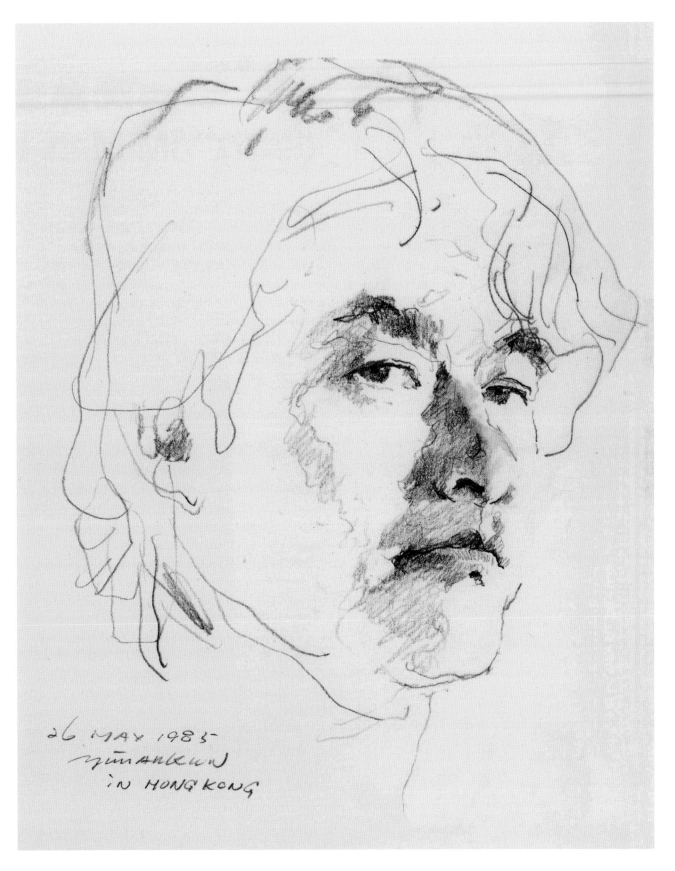

26 MAY 1985
YIN AN KUN
IN HONG KONG

ABOUT USING VALUE

In sketching, value has a rhythm of its own.

- Value should be used where it can convey volume and height differences.

- Use for key features such as the head and hands.

- Use value for large blocks of black, gray and white.

- Use value to convey the texture of the subject.

- Use value where it can create strokes.

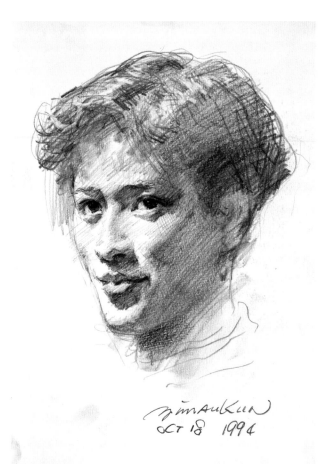

COCO YU
Pencil on paper, 11¾" × 8¼" (30cm × 21cm), 1994

much detail. Sketching should be relatively fast but is not all about speed. Start slow, then gradually speed up.

Start with a draft, using pale, light lines to define the areas, proportions and dynamics before putting pencil to paper. Do not draw any details at this point. Once the draft is ready, work outward from the key parts such as the head and hands.

Use straight, angular lines, then contour lines. Sketches can be a little angular like those of Mikhail Vrubel, or be a little more curvaceous like those of Adolph Menzel. If you are new to sketching, however, using more straight lines will make capturing relative proportions and dynamics easier. This technique is often used at the Soviet Academy of Arts during sketching classes. Straight lines may seem a little less sophisticated, but the main features and proportions will remain true. Contour lines may seem more lively, but they can run wild like a mustang in unskilled hands.

When you start practicing sketching, avoid adding value. Get rid of the backgrounds altogether as well. With lines, what matters are the edges of shapes. Get this right and the rest can be ignored or reduced.

RELY ON MEMORY

When sketching, observe the subject as a whole. To avoid distorting the perspective, don't approach the subject too closely. Slightly narrow your eyes when observing and do not fix on a point. Don't glance up at the subject with every line. You should instead draw a small area for each glance. This is a process of rapid observation and memorization. In other words, half of the work in sketching depends on memory. This is a part of the sketching technique and also what makes it click. Many people don't understand this so they look up with every stroke and still haven't mastered sketching after a lifetime of trying.

LOOKING BACK
Charcoal on drawing paper, 20"× 12½" (51cm × 32cm), 2010

This sketch really captured the essence of the moment. The head and face made minimal use of the tortillon (a tool made of rolled paper used to smudge or blend charcoal) and white pencil. For the hands and clothing, I got everything down on paper in a freehand style.

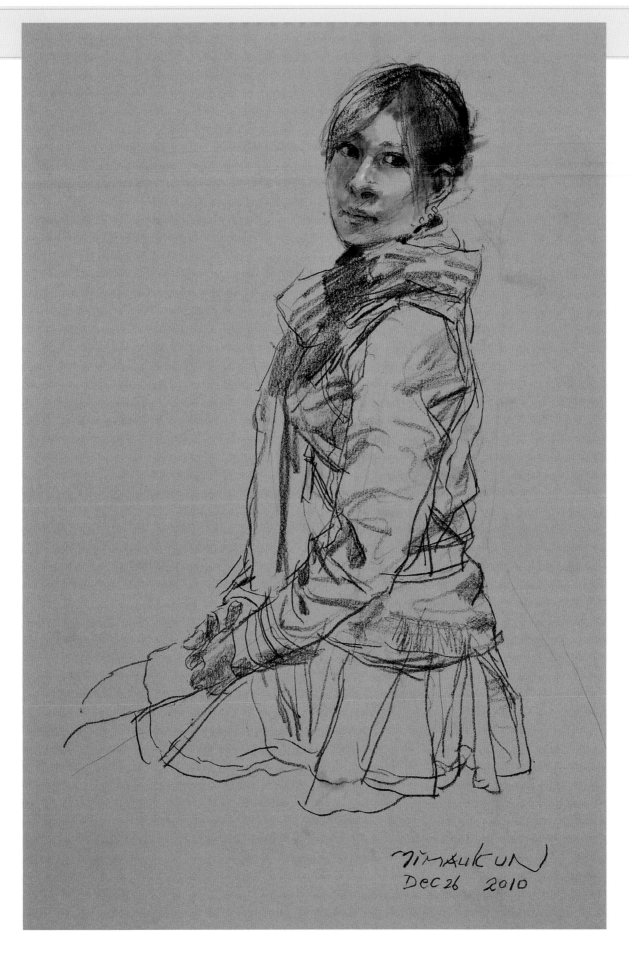

IMPORTANCE OF ANATOMY

To draw well, you must know your subject. To draw a portrait well, you must have a knowledge of anatomy. Leonardo DaVinci was the first artist who studied anatomy. He used geometric analysis to figure out that the length of the human body is eight times the length of the head. This is the most ideal proportion. At the same time, he suggested that artists should be knowledgeable about muscles, tendons and bone structure. These scientific approaches form an important foundation for proportion and composition in figurative drawing and painting.

CHARACTERISTICS OF THE SKULL

The skull is very important for figurative drawing. Some art training programs include a drawing study of the skull. Major parts of the skull include the frontal bone, the cheekbones, the upper jaw and the lower jaw. The skull can be divided into two parts. The upper part—from the upper jaw to the frontal bone—is fixed, whereas the lower jaw can open and close to talk or eat. After you understand the characteristics of the skull, you need to look at the details of the bones.

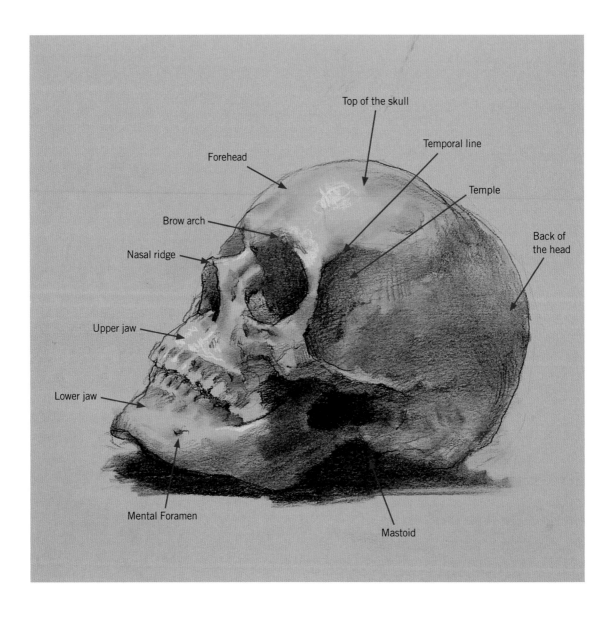

Top of the skull

Temporal line

Forehead

Temple

Brow arch

Back of the head

Nasal ridge

Upper jaw

Lower jaw

Mental Foramen

Mastoid

Forehead: The front of the forehead has a small flat area. For some people, the front is pointed instead of flat. But in general, it's flat.

Temple: The anatomical term is temporal fossa. Older people have fewer muscles so it's more visible. But in younger people, the temple is usually covered with muscles.

Temporal line: This is a very important characteristic. Older people have clear temporal lines.

Brow arch: It's also called supraorbital foramen. Because it arches, it's also called the supraorbital arch.

Cheek bone: Some races of people have big cheekbones; others have smaller ones. Europeans and Americans have smaller cheekbones. Asians, especially Mongolians, have large cheekbones.

Nasal ridge: The nasal ridge is rather short. Further down there are the tip and wings. These are cartilages.

Upper jaw: Unlike the lower jaw, which is movable, the upper jaw is attached to the nasal ridge and cheekbones and is fixed. In terms of basic shape, it's a half cylinder. The upper lip is on top of the upper jaw, so it's also a half cylinder. Beginning artists often focus on the upper lip and forget about the fact that it's a half cylinder. This is due to a lack of understanding of the upper jaw.

Lower jaw: Also called the mandible, the lower jaw usually has two points called mental foramen. The jaw angle is a very important characteristic in anatomy.

PRACTICE, PRACTICE, PRACTICE

According to the standard of classical fine art training, there are three types of drawing studies.

- Short-term study: Less than 10 hours
- Medium-term study: 10–20 hours
- Long-term study: 20 or more hours

Short-term studies are very important. You can use the skills developed in short-term studies to draw your colleagues, friends or family. But if there is no long-term study to lay the foundation for in-depth analysis and understanding, a short-term study will appear empty and lacking in content.

Mastoid: Muscles attached to the mastoid connect the clavicle and sternum beneath it. This is a very important part. The sternocleidomastoid is connected to the mastoid, sternum and clavicle and serves to turn and nod the head. When a sitter is in a position that turns his head, this muscle is quite visible. If the subject is not very thin, you won't be able to see it.

Back of the head: Back of the head varies from person to person and is a result of sleeping habits during infant stage.

Top of the skull: This is the width of the skull. The areas above the ears are the widest points of the skull, but are covered by hair. This area is often neglected.

THE IMPORTANCE OF SKULL STUDY

Skull study is a must for a figurative artist. The skull is the internal structure referred to beginning on page 18. It provides a structure for facial muscles and skin and has its own characteristics. Solid understand of the skull helps you render convincing likeness of the head.

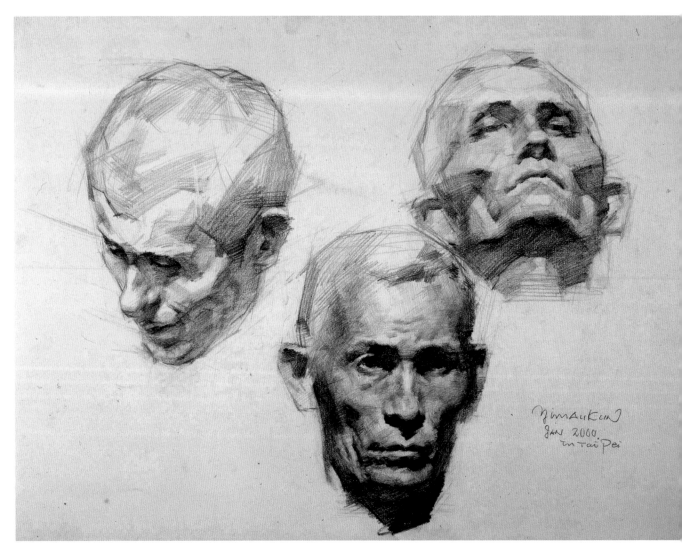

HEAD STUDY
Pencil on drawing paper, 19" × 25½" (48cm × 65cm), 2000

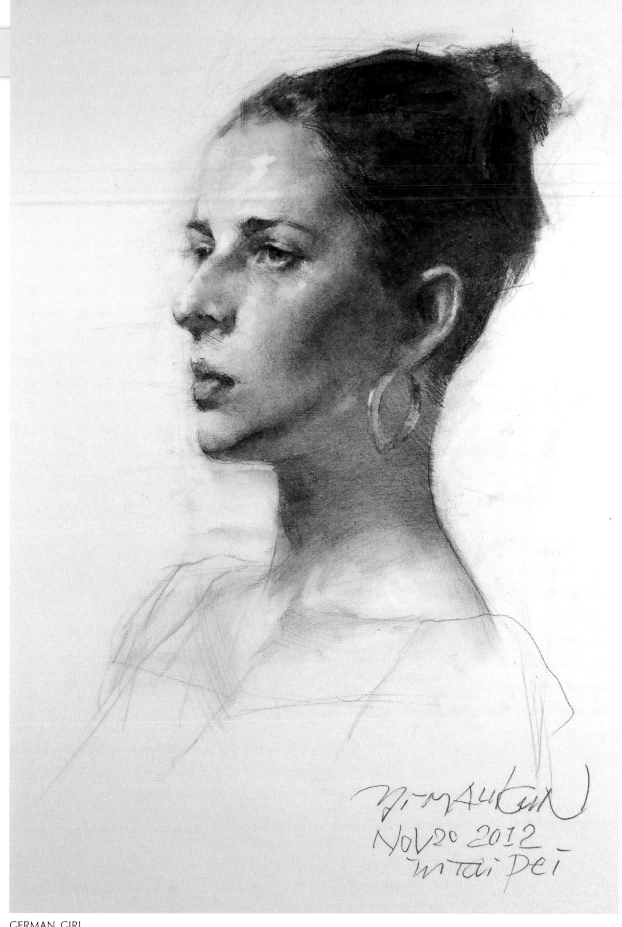

GERMAN GIRL
Charcoal on drawing paper, 24" × 20" (51cm × 32cm), 2010

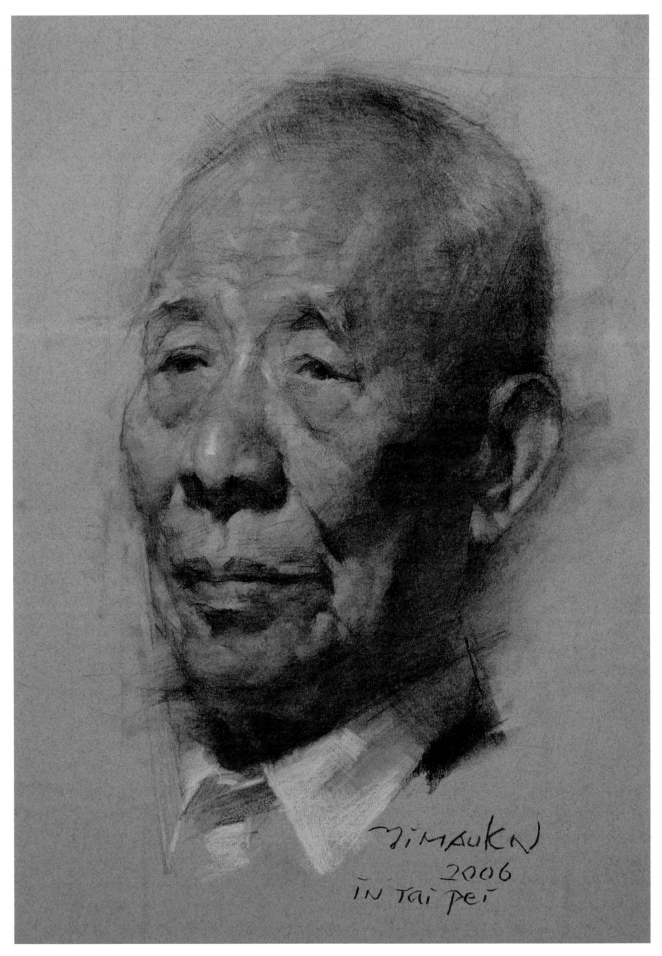

MIMAUKN
2006
IN Tai pei

DRAWING THE HEAD

IN THIS CHAPTER, you will learn a step-by-step process for drawing a head, from block-in to adding values, and then to rendering details. You will also learn how to approach drawing the head holistically so that all the parts, details and value work together harmoniously to compose a portrait that resembles the subject in likeness and spirit instead of any part jumping out of place. Lastly you will learn to think critically in your analysis and rendering of the subject so that the drawing has the same artistic quality of an oil painting with brushstroke effects created with creative use of a variety of tools.

I use the same process whether I'm drawing a plaster cast or human, except that when drawing a human, I will attempt to interact with the subject to gain a better understanding of the person's personality in order to capture the spirit in addition to likeness.

OLD MAN
Charcoal pencil on drawing paper, 24" × 20" (51cm × 32cm), 2006

TOOLS

Depending on the style of the drawing that you would like to create, there are a variety of tools to help you achieve different effects. For example, pencil for detail rendering, charcoal for texture and charcoal pencil for its versatility since it has the characteristics of both pencil and charcoal.

Sometimes I use different tools for different stages. For example, I use a charcoal stick to block in and then switch to a pencil or charcoal pencil for adding value and details.

Pastel paper: The back of the pastel paper is smooth and suitable for drawing. The pastel paper is light gray, so highlights can be created using a white pencil.

Charcoal stick: Use a charcoal stick for the first two steps of the drawing process. Charcoal sticks are lighter in color than charcoal pencils. Using a charcoal stick during this stage also makes it easier to make adjustments since charcoal powder is easy to rub off.

Charcoal pencil: Use a charcoal pencil for adding value and details. A charcoal pencil has the characteristics of both pencil and charcoal and can render a drawing with the effects of both tools. It allows for the details and precision of pencil and the strokes, texture and free-flowing style of charcoal. Using charcoal pencil together with tissue paper and a blender can create rich variations in value and texture.

Charcoal pencil produces a darker color than pencil. The dark color won't reflect light. Avoid making marks too dark when using a charcoal pencil unless those marks are intended. Otherwise, it's hard to make revisions later.

Tissue paper: Use it to soften lines, edges and hatching.

Blender: Use it to soften lines, edges and hatching in small areas. I use small, solid blenders commonly available in art supplies stores for details. I also make bigger blenders using rice paper and use these to soften large areas such as the backdrop.

Erasers: Use a soft eraser that is flexible and can be shaped to a point for creating small details. Use a solid eraser to effectively remove pencil marks; it can also be used to create highlights.

White pencil: Because you are using a gray pastel paper for this charcoal pencil drawing, you'll need a white pencil to create highlights.

The use of a white pencil needs to be precise and to the point. Use it selectively where it's most needed, such highlighting the eyes or the tip of the nose.

I use Iken Art-Char brand charcoal sticks. They are less compressed than other brands, which makes them appropriate for the block-in process because you may want to get rid of these marks later.

From top to bottom: Charcoal pencils, tissue paper for blending, blenders, paste (kneaded) eraser, piece of rubber from a flip-flop for blending and creating strokes, white crayon for highlights, abrasive paper (sandpaper) for sharpening the crayons

Pencils, tissue paper and blenders

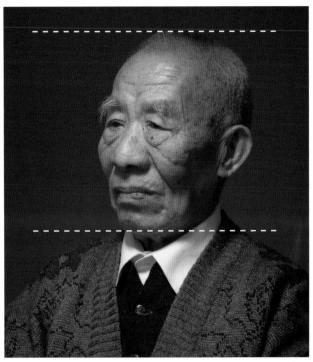

Top and bottom boundaries

BLOCK IN

The first step in drawing a head is to block in the shapes. For this step, I use a charcoal stick. Below are the six guidelines for this step.

1 *Define boundaries*
Map the position of the head by marking the top, the bottom, and the left and right boundaries. Use straight lines to define the boundaries of the head. Use straight lines to define the dividing line between the front and the side of the face.

2 *Use straight lines*
When blocking in, don't use curved lines to fit the contour. It's easy to make mistakes that result in incorrect proportion or perspective. Using straight lines allows you to observe the subject as a whole and examine the relationships between key blocks and define those relationships correctly on paper.

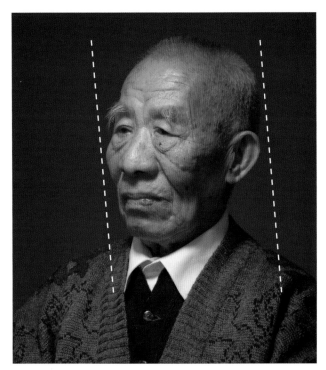

Left and right boundaries

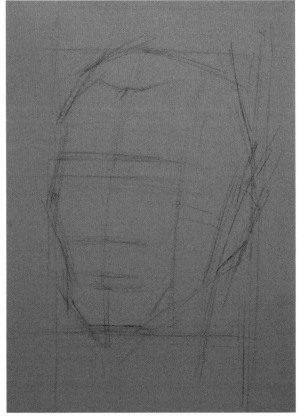

Blocking in

3 *Define locations of the parts with reference lines*
Define the middle line of the face. The angle of the middle line of the face sets the tone for the dynamics of the head. Then draw the reference lines for the eyes, nose, eyebrows and mouth. The rule of thumb for the head division is one-third for the hairline to the eyes, one-third for the eyes to the bottom of the nose and one-third for the bottom of the nose to the chin. These reference lines may vary depending on the position of the artist to the model and the resulting perspective.

4 *See the forest, not the trees*
At this stage, focus on studying and exploring the proportions and relations of the shapes. Avoid drawing details such as the pupils and nostrils.

5 *Define large areas*
Continue to use straight lines to define large areas where planes connect and shadow areas, such as the front, sides and slopes of the forehead, as well as the front, wings and base of the nose. Mark the approximate shapes and positions of the brow arch, cheekbones, temporal bones, chin and jaw.

When drawing the ear, pay attention to its relationship with the eyebrows, the eyes, the wings of the nose and the nose. The bottom of the ear is level with the bottom of the nose. When you're drawing a straight line across the face, you can examine the distance between the highest point of the ear, the eyes and the eyebrows. Similarly, use straight lines to examine the distance between the ear and the nose wings to get the proportion right.

6 *Make it three-dimensional*
The block-in should have a three-dimensional feel. It should reflect the accurate locations of parts and relationships between them; it should include locations of the shadows, have proportion, and show depth.

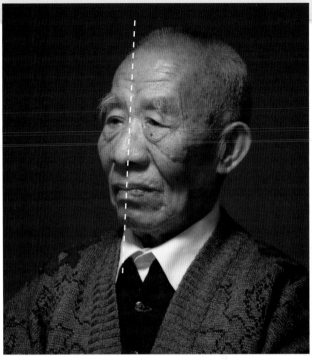

Middle line of face

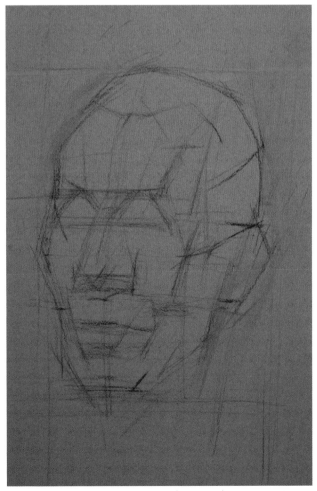

Define key planes with straight lines

FURTHER DEFINE THE PARTS AND MAP THE STRUCTURE

For this step, I still use a charcoal stick. Below are the guidelines for this step.

1 *Build volume while blocking in*

Blocking in doesn't mean you draw only an outline. You also add volume. You use blocking in to express the appearance of the subject, but the block-in also has structure. Structure refers to two things: the basic geometric shapes and the structure of bones and muscles. The outside shapes and angles are closely related to the inner structure. It is essential for an artist to gain anatomical knowledge in order to create a precise and accurate drawing.

2 *Define the features, starting with the nose*

After the initial block-in, start with the nose. The nose to the face is like the ridge beam of a house. So if you get it right, you can use it as a benchmark for the other parts. When working on the nose, also mark the division between light and dark. Defining this line helps convey volume and shape later. Add the shadow of the nose then examine the size and location of the nose in relation to the other parts.

3 *Define the eyes*

Focus on the entire shape of the eye instead of drawing the eyeball in the beginning. Don't add details to the eyeballs during this stage.

A common mistake is to make the eyes either too high or too low. Even an experienced artist needs to pay attention to this part. If the proportion is inaccurate, it affects the entire drawing.

4 *Define the lips*

Find the medial cleft above the upper lip then define the slopes on both sides of the cleft. Find the middle point (the *V* shape) of the upper lip then define the upper lip. Define the thickness of the upper lip and then the width.

Continue onto the lower lip. Define the shape and shadow of the lower lip.

5 *Define the chin*

Pay attention to the chin. Part of the chin is in the light and part of it is in the shadow. Together they make up the chin.

6 *Employ the principle of symmetry*

In order to relate parts to the whole and accurately define the locations of the parts, employ the principle of symmetry. Pay attention to both sides of the face. For example, when you draw the wing of the nose on one side, draw the wing of nose on the other side. When you draw the left brow ridge, draw the right one. Look for symmetry in everything that's visible and also examine the location and size of the parts. This way everything is symmetrical, including perspective.

PROPORTIONS OF THE HEAD

The head can be divided into the following proportions.

- One-third from the hairline to the eyebrows
- One-third from the eyebrows to the nose
- One-third from the nose to the chin

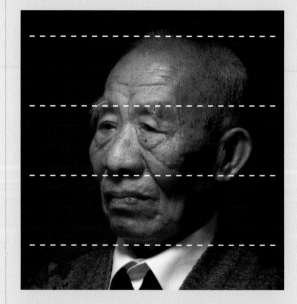

The width of the head (from cheekbone to cheekbone) is about two-thirds of the length of the head.

The proportion varies slightly from person to person, so look for the slight differences in each subject.

7 Soften the edges

Lastly soften the lines and edges with tissue paper or your hand to prepare for the next stage.

There are two approaches going from here:

1. Add details to parts of the head and then value
2. Add value to large blocks and then move onto details of the parts.

WRINKLES

Avoid defining the wrinkles during this stage. It's common to think wrinkles are very visible and clear. But they're not really as visible as they appear, nor should they be addressed at the block-in stage of the drawing.

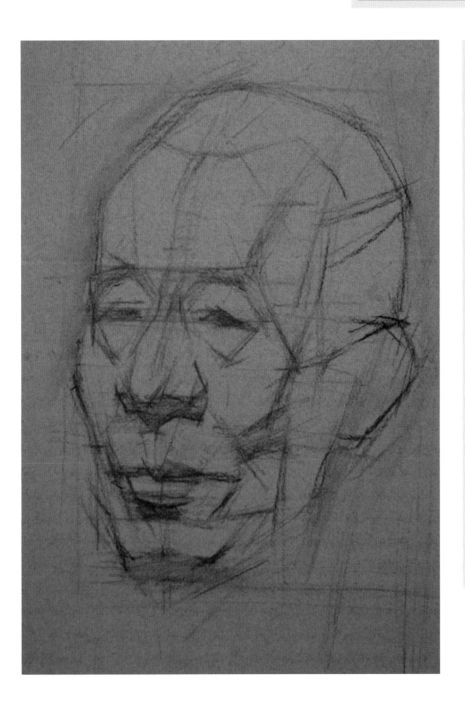

TIPS FOR DEFINING FEATURES AND MAPPING STRUCTURE

- Except for the shadow of the nose and the chin, don't add value during this stage; you'll add value in the next stage.

- Capture the form and volume of the subject by defining large blocks; define the size, shape, height, width and length of these blocks.

- Don't use a single contour line for the edge. Instead, use straight lines to capture the edge of different parts. You will be able to accurately capture the parts this way compared to using a single contour line to trace the edge.

- During this stage of blocking in, you need to pay extra attention to the proportions of eyebrows, eyes, nose and ears and re-examine the symmetry and relationships. Don't move onto the next stage until all the facial features are accurately defined.

ADD VALUE

All objects have light, middle and dark values when exposed to light. In the seventeenth century, Flemish Baroque painter Peter Paul Rubens noted that the light and dark of a painting should not exceed one-third of the painting. Two-thirds of the painting should be reserved for the middle tone. The so-called middle tone refers to the middle ground when the temperature of color changes. The same applies to a drawing.

Blocking-in builds the structure of the head. Darkening the shadow, as you will do in this step, makes the facial parts stand out. The middle tone enriches the entire drawing.

For this step, I use a 4B charcoal pencil for hatching. Below are the guidelines for this step.

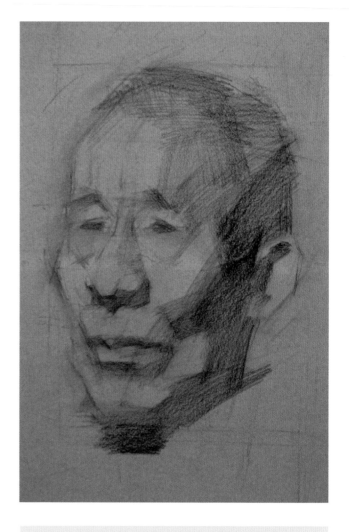

1 *Shade middle value*
During this stage, shade the shadow with middle value then add the major middle value blocks. Ignore details and the highlighting of the dark areas at this point.

2 *Hatch dark areas*
Hatch all the dark areas at one time. The division between light and shadow and the edges of the shadow should be concise and precise.

3 *Hatch shadow of nose*
Hatch the entire shadow area of the nose. A common mistake is to define the nostrils at this point. Doing so would make them too dark and out of place in relation to the rest of the drawing.
Continue onto the cheekbone and the other areas.

4 *Use straight lines*
Drawing is like sculpting a piece of marble; don't delve into details too early.

5 *Soften and add texture*
Lastly use tissue paper and a blender to soften the skin tone and texture and increase variations of the middle value.

TIP FOR ADDING VALUE

Don't make the dark areas too dark at this stage; instead, replace the dark with gray so that it's easier to modify the dark areas. Once the dark areas are defined, the foundation of the drawing is done.

FURTHER DEFINE FEATURES AND THE MIDDLE VALUE

1 *Draw the nose*
Use accuracy and details because the other facial features rely on the nose as a baseline for positioning.

2 *Create highlights*
Since the pastel paper used in this drawing is light gray, you can create highlights using a white pencil. Use a white pencil to define the highlight of the nose, the lightest point in the entire drawing. Then define the highlight of the upper part of the nasal bone.

3 *Further define middle value*
Use a lighter charcoal pencil for middle value areas. Since charcoal pencil has a darker tone, be careful when using charcoal pencil on light areas.

Shade the entire area first, then highlight the lighter parts using an eraser and use a charcoal pencil to emphasize the darker parts. This is a process of repetition. Whenever you work on details, you need to re-examine the location and shape of the different parts. At the same time, pay attention to strokes. For example, there are hard and soft edges in the shadow of the nose; don't make it all the same.

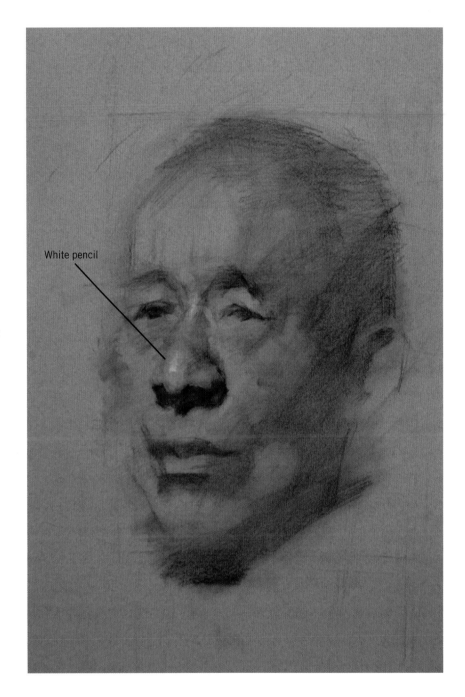

White pencil

ADD DETAILS

1 *Create details faithfully yet selectively and aesthetically*
At this stage, pay attention to the shapes, values, details and the strokes you create. With a variation of hard and soft edges as well as diversified pencil strokes, the drawing comes to life and the process of drawing is more enjoyable.

While the drawing needs to be faithful to the subject, to create a drawing with aesthetic value, you need to employ critical thinking, establish priorities and be selective in your approach.

Render the details of variation in value and edges, and transition and connect the different planes in local areas.

You should not make everything too smooth and detailed in the drawing. The drawing should contain strokes and texture similar to what you can find in an oil painting.

2 *Convey the spirit of the subject*
Spirit and mood can be captured in a few places, including the corners of the mouth, the eyes, eyebrows, nostrils and nose. The bridge of the nose is fixed but the nostrils will move because of muscle movement. The mouth moves quite a bit. So do the eyebrows. Over the years, habitual facial movements will create a person's unique look. Capture the parts that represent the subject's unique look.

3 *Be aware of challenges, create details with critical thinking*
At this point you may be feeling challenged by the process. If you feel your head drawing is lacking structure, i.e., bone structure, remember that knowledge of anatomy will help immensely. If you are concerned about a lack of detail, know that there are many details to each part of the head. This can be confusing or challenging to a beginning artist. It is not possible, nor is it necessary to include every single detail. Use your critical thinking to detail the rendering instead of blindly creating all details to resemble a photo.

4 *Detail the eyes*
The eyes are the windows to the soul, so take extra care when detailing them. Start with the soft edges and then move on to the hard edges, i.e., the areas with dark values and strong contrasts.

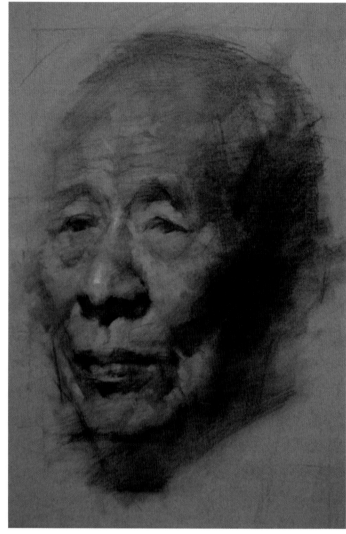

Refined forehead, mouth, refined the value on cheeks and jaw

The eyelid is three-dimensional. Because the eyelids block out some light, the eyes are not that white. Inexperienced artists usually make the white part of the eye too white. The eyes of a senior are not like those of a child; the eyes of a child are much sharper.

When drawing the eye bags, similar to the wrinkles, don't make them stand out too much or appear out of sync with the rest of the face.

The highlight on an eyeball is very small. If you make it larger than it should be, the eyes look dull and the drawing will lack life.

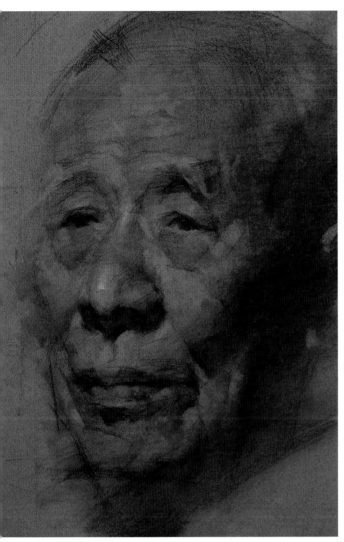

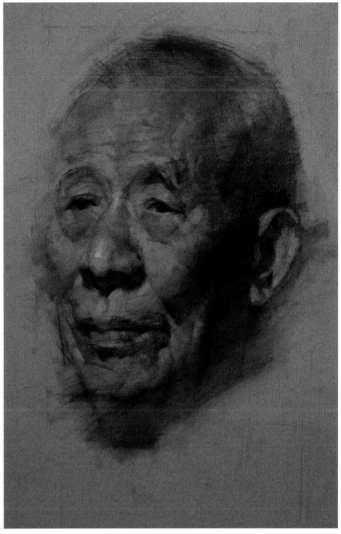

Refined hair at the top, eyes, eye bags, refined value around the mouth

Refined hair at the top and ear

5 Detail the nose
A common mistake is that we sometimes make the nostrils too dark and too defined. The nostrils should be inside the nose in the shadow.

6 Detail the ears
What's the difference between an old man's ear and a young man's? The shape of an ear won't change throughout a person's lifetime, and there are no wrinkles. But the earlobe does change over time. Earlobes for older people tend to get a little bit droopy.

RENDERING WRINKLES

Older people tend to have more wrinkles on their faces, which can be challenging to draw. But the wrinkles themselves also make a drawing interesting by enriching the drawing with texture and details. When working on the lines and wrinkles, keep in mind two things. The wrinkles should not stand out and appear out of sync with the rest of the drawing. Secondly, the wrinkles need to correspond to the shape of the forehead. Focus on conveying an impression of these wrinkles. Avoid making every single wrinkle visible.

First capture the basic characteristics of the ear, including the helix, antihelix, tragus and earlobe. The ear should not pop out. Avoid using contour lines to call out every detail of the ear. To make sure it's in sync with the rest of the face, compare it to the nose and the cheekbones. The ear needs to be behind the cheekbone at an angle. The hard edges of the ear are different from the hard edges of the cheekbone. If we make the ear too dark, it doesn't seem to be under the light. But it's inappropriate to make the ear too bright either because the spatial relationship will be incorrect.

Pay attention to the light and shadow areas. For the light areas, there are different levels of brightness. Focus on the overall shape of the light and dark areas.

7 Detail the hair and hairline

It's impossible to draw hairs one by one, but you can seek to represent the impression of the hair. When you draw the hair, you need to pay attention to hair blocks, the shape of the blocks and the relationship between the hair in the front to the hair in the back. You're also drawing the spatial relationship between the hair and the skull. The hair should cover the skull instead of pop out of it. Keep in mind the overall shape, the overall variation in edges and value and the overall artistic feeling.

Refine the lines and the layers on the forehead and make them consistent with the hair.

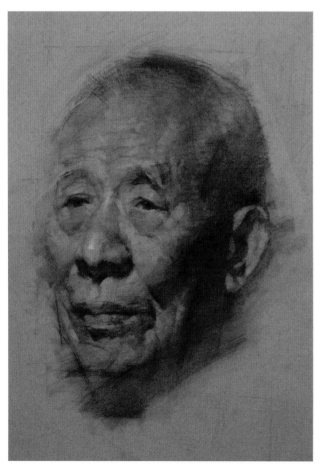

Refined shadows and wrinkles

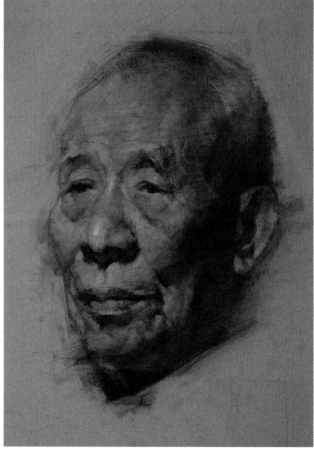

Refined the edges on the left, the ear, and value beneath the jaw

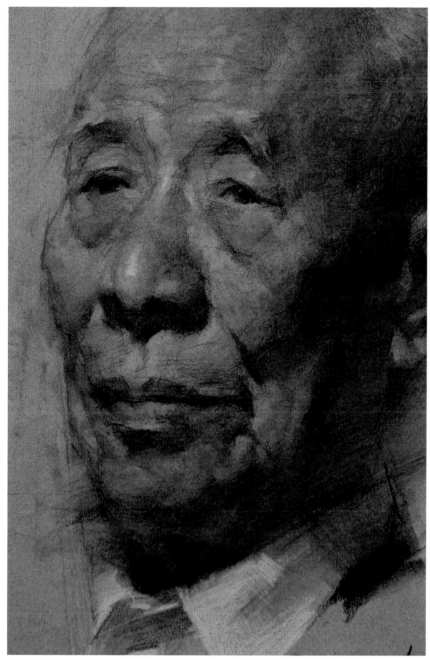

Refined hair and added white collars

TIPS FOR ADDING DETAILS

- Before you delve into the details of the facial features in a head portrait, you first need to have in-depth knowledge of head anatomy. If a head portrait is lacking in likeness and spirit, it's often due to a lack of understanding of head anatomy. As a result, the bones and muscles are out of sync.

- When you work on facial features in detail, avoid working on facial parts one at a time. Work on the face as a whole.

- When you work on details, you may sometimes be overly meticulous and forego broad strokes. Sometimes I purposely "sabotage" some of the finished areas slightly because I'm worried that the drawing is too identical to the subject and therefore will lose the aesthetic value—the interesting part of a drawing.

- When observing, look at the sitter with a squint, feel the rhythms in the details, and then translate them to a variation of strokes to bring the work to life. At the same time, pay close attention to the personality of the sitter, especially his eyes and mouth. Observe carefully and draw with passion to vitalize the image.

- For the light areas, pay attention to the half tone. For the dark areas, pay attention to the variation in dark value. Make sure it's not overly simplified and smooth. Lastly, remember to keep the feel of "facets" (the smaller planes in each area) of different parts.

FINISH UP

1 Re-examine everything

Re-examine the shape of the head. Is it faithful to the subject in likeness? Is it faithful to the subject in spirit?

Re-examine the value of the drawing—the light, the midtone and the dark. Each of these three major values should be further divided into three more values, plus the highlight (the brightest point). There should be ten values. Renowned Chinese painter Xu Beihong said that if a painting has ten values, then it's a good painting. It's the same for drawing.

Re-examine the edges of the face. The edges should not be one continuous line. These edges should have rhythm, spatial relationships and variation. Make sure there is a relationship between the front and the back. We need to interpret the concept of lines in terms of volume. the edges of the face (composed of multiple lines) should convey a sense of volume which one continuous line will not do.

2 Fine-tune to convey wholeness

Sometimes in the middle of working on part of the drawing, I realize did something less than ideal elsewhere. When this happens, I will revisit that part spontaneously. It will seem that I'm randomly drawing here and there, but this randomness is conducted with the aim of consistency. The purpose of this randomness is to make the drawing more unified. So when I discover some part is inconsistent or not ideal, I refine it.

ABOUT THE MODEL

Mr. Lee's wizened and weather-beaten face and thinned hair convey perseverance in his eighty-four years of life. The sitter was born in my hometown province of Hunan, China. A graduate of traditional Chinese-style homeschooling, he served as a secretary in the National Party's army during the Civil War. He came to Taiwan with the Chiang Kai-Shek government more than fifty years ago and married a Taiwanese woman. Even though he retired years ago, he still keeps himself busy. In recent years, he has made his living collecting and selling recyclables near our studio. Every time I invite him to sit for me, he always comes early and is neatly dressed. When I give him the modeling fee at the end of each session, he's always very grateful, utters many words of thanks, and bows when he receives his money. We are all moved by his formal, traditional way of showing his gratitude.

3 Refine the shadows

Reinforce the boundary between light and dark on the chin to make the chin more solid. In the process, gradually and softly represent the structure and texture. Many people make shadows overly sharp, especially those in wrinkles and folds. Employ a general and impressionistic approach when working on shadows. Don't make the details in the shadow too distinctive. After refining the shadow as a whole, use an eraser to highlight the details a little bit. At the same time, pay attention to the rhythm of the shadow. There should be variation in the shadow, a further breakdown of different levels of darkness and a further breakdown of planes.

4 Go slowly

During this stage, you need to deliberate over every detail, making some a little bit darker, some a little bit lighter, softening some edges and hardening others. You're almost done with the drawing, so think about the likeness of details and the handling of the strokes.

5 Add final touches

Make some final adjustments to the face. Some places require reinforcement. Make sure every part is consistent overall with the drawing and has variation in value and clear relationships between the planes of the form. At the same time, make sure the color is lively, i.e., with variation in value and edges. Every part should be breathing. If it's not breathing and everywhere has the same dark value and same light value, the whole part will appear dead and dull.

6 Know when to stop

When is the right time to stop drawing? To answer this question, you need to examine the drawing as a whole. Determine whether anything is missing and whether there are unnecessary details. A drawing will never be exactly like the subject, and it doesn't need to be. It is, after all, a drawing, not a photograph.

If, when we're done, the drawing is very smooth like a photograph, then it's problematic. During the last examination, the purpose is to make sure it's not too smooth and doesn't have too many details. If there are too many details, it will undermine the wholeness of the drawing. Examine everything with a critical eye.

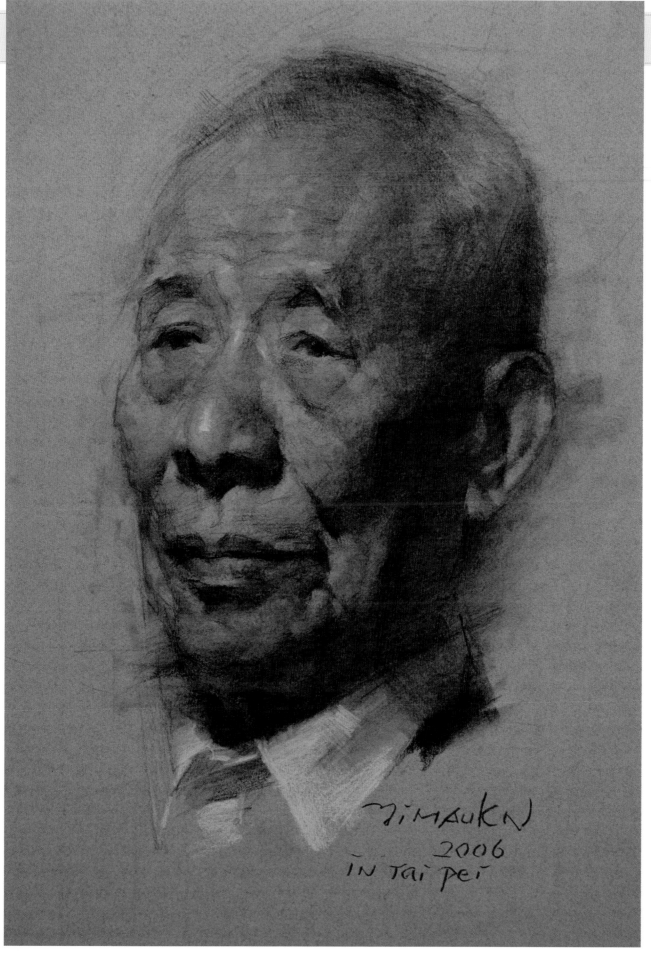

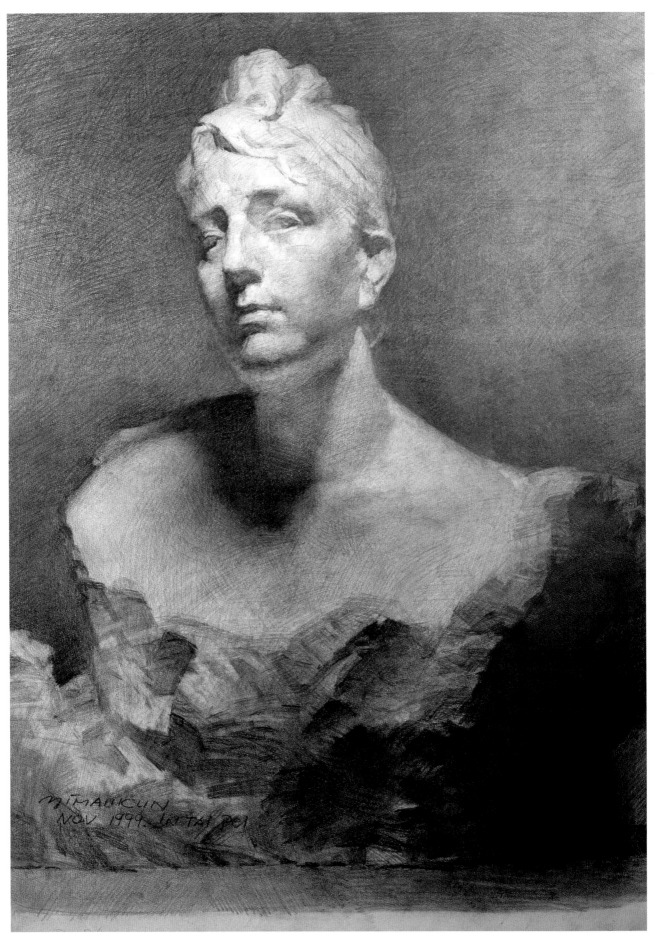

CLASSICAL BUST DEMONSTRATIONS

IN THIS CHAPTER you will see how the same approach employed in the previous chapter—using straight lines for block-in, planar analysis, value and detail rendering and iteration throughout the process—is used here as well. I would strongly recommend that you start with classical bust study before moving onto live model drawing. Even if you have been doing live model drawing, but have not done any classical bust study, it's still worthwhile to go back and study classical bust drawing. Confucius said, "Reviewing what you have learned and learning anew, you are fit to be a teacher." I can't emphasize enough the importance of classical bust study. My solid training in classical bust study has benefited me throughout my painting career.

MADAME VICUNA
Pencil on drawing paper, 24½" × 18½" (62cm × 47cm), 1999

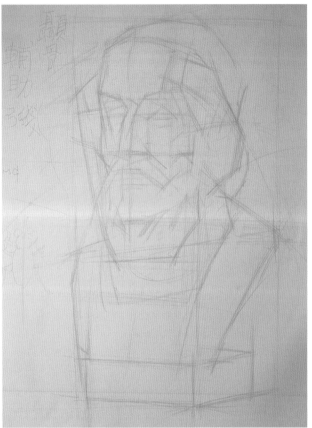

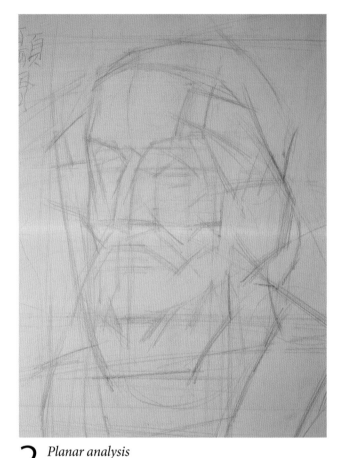

1 Block in

First, evaluate the position of the sculpture from every direction. Use reference lines to establish the positions of its top, middle and bottom areas. Find the center point of the sculpture (around the core shadow area under the chin), then locate the mid-point of the sculpture head (around the eyes). Divide the forehead into thirds, as well as the area between the eyebrows and the nose, and from the nose to the chin. Finally, block in the hair, mustache, chest and base.

The most important point is to use straight lines at different angles to define or cut out the shapes. Omit curves and simplify the subject. This is the key to grasping the shape of the sculpture.

2 Planar analysis

When focusing on the facial features, distinguish between the front and sides of the face. Mark the lines at the eyes and the mouth, and then find the midline of the sculpture, located halfway between the eyebrows. After the line is drawn, the side closer to you will appear larger due to perspective. Then draw the different dimensions of the nose: its front, sides and base. Position the rest of the facial features in relation to the nose. Pay attention to the bone structures that create shadows and curves, such as the brow bone, nasal bone, cheekbone, temporal bone and mandible. Also, locate the areas where large differences in value occur.

The process may seem very abstract, but it is a key step to adopting a three-dimensional viewpoint on a piece of two-dimensional paper.

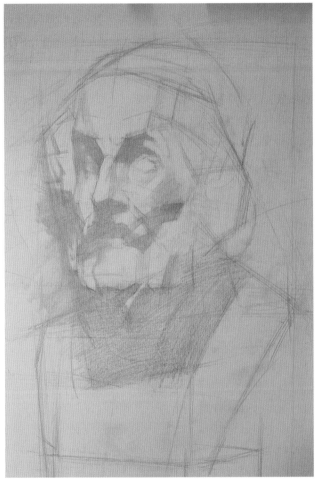

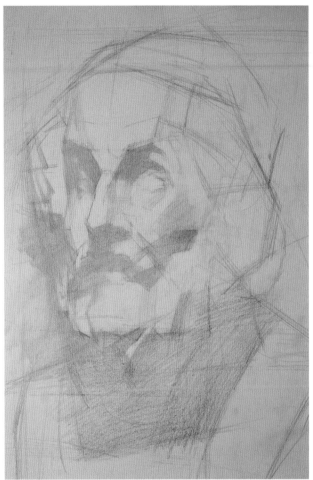

3 *Continue planar analysis*
All objects have light, middle and dark values when exposed to light. The block-in should include not only block-in of key parts of the plaster cast but also the dark areas. In this case, it would be the side planes of the nose, cheeks and forehead.

The trick is to not make the dark areas too dark. Instead, I use the middle value to block in at this stage so I can easily make revisions to the shape, position and size at later stages. Once the dark value is fixed, you'll have difficulty changing it, so for now, keep the dark areas lighter than you want them in the final drawing.

4 *Add value*
The dark value areas should be treated as a whole at this stage. Create general, big blocks and leave out the details. In this respect, drawing works in the same way as sculpting. It is not necessary (nor is it possible) for a sculptor to carve small details during early stages.

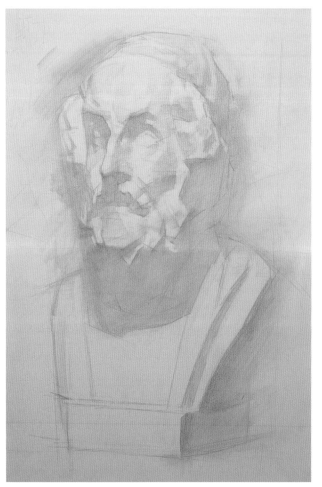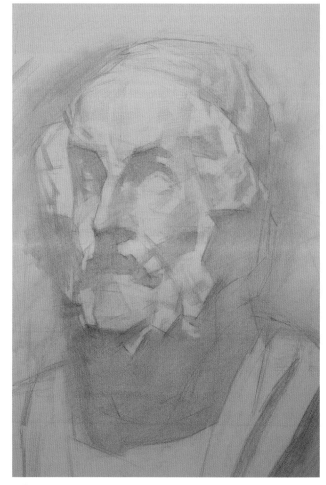

5 *Continue to add value*
Further define the dark areas, moving up from the back of the head to the hair, chest and base and down to the background. These efforts create harmony, focus, depth and, as a result, aesthetic beauty for the drawing.

It is extremely important to develop the skill to examine all parts of the drawing as a whole and not be tied down by the details. If this skill is not acquired, you will make the mistake of seeing the tree but missing the forest.

6 *Re-examine perspectives*
Many artists make mistakes in drawing because they fail to grasp the concept of perspective. When this happens, you might make small shapes or facets larger and wider than they really are. In this drawing, if Homer's right forehead, cheek, eye and beard were any wider, the drawing would become too flat and lose its three-dimensional feel. It is important to note that the face only looks symmetrical when viewed from the front. When the sculpture's angle is tilted due to perspective, the facial features are no longer symmetrical.

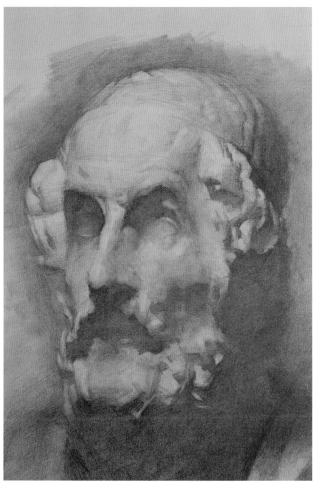

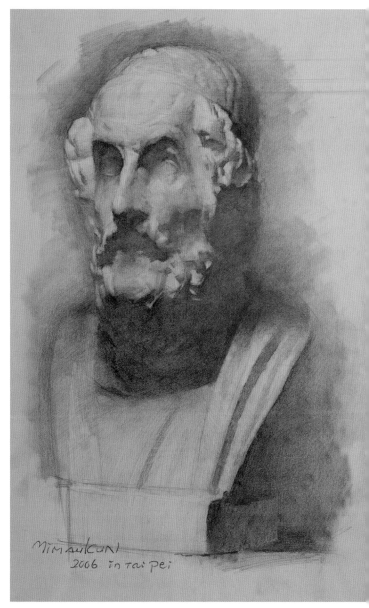

7 Create details

To create detail, you need to follow your instincts. There are two kinds of instincts. One is uneducated and untrained. It offers too many details, resulting in incoherent drawings that lack interrelation. The other is trained instinct, leading to holistic observations that help to create coherent drawings with a strong focus and precise values. This is the right instinct.

Drawing details requires you to observe carefully and analyze thoroughly in order to accurately represent the transition in value and edges in a small area. A few things to keep in mind: First, in light areas, pay attention to transition in physical surface and form; in dark areas, pay attention to transition in value and soft edges. Second, don't make the drawing overly smooth. Reserve the feel of "facets" in the drawing.

8 Finish up

Lastly, reinforced the dark areas even more, including the core shadows and some borders of the plaster cast shadows. This adds to the weight and strength of the plaster cast sculpture, making the dark areas seem slightly airy.

HOMER
Pencil on drawing paper, 24" × 20" (61cm × 51cm), 2006

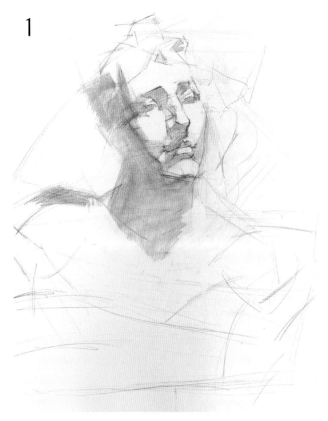

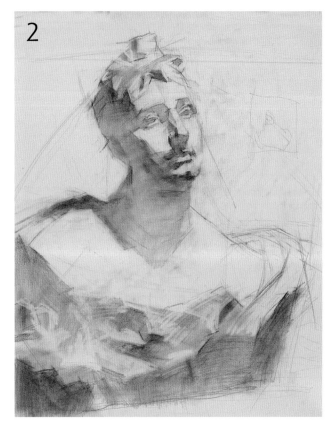

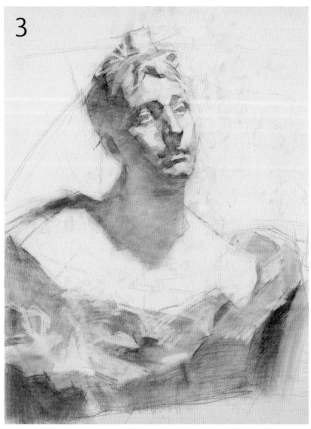

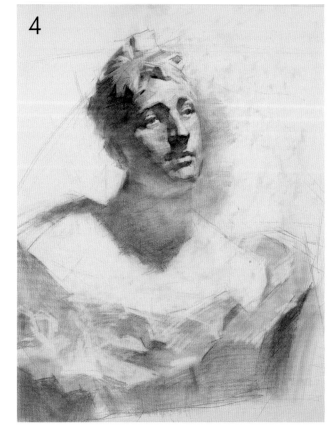

For drawing this Rodin sculpture, I used a combination of hatching and rubber eraser to create the texture of the sculpture, to differentiate stone from skin, leveraging the versatility of pencil. I created a full backdrop to convey a sense of space, music and air.

This drawing is relatively straightforward in that there is strong contrast between the flesh and the base of the bust which is easy to render. The key to the drawing is the slight tilt of the head and the relationship between the head and the chest. This relationship between the head and the chest must be established from the very beginning during the block-in. To establish this relationship, find the middle line that goes through the nose and the line that goes through the eyes. These two lines must be established at the right angle. If you're not sure, extend your right arm holding a pencil horizontally. Anchor the pencil at one of the eyes, the other eye must be either above or below the pencil.

1. Build the structure of the classical bust.

2. Identify key dark areas and apply gray.

3. Reinforce dark areas and light areas.

4. Create details and further define nuances in the dark, middle and light values.

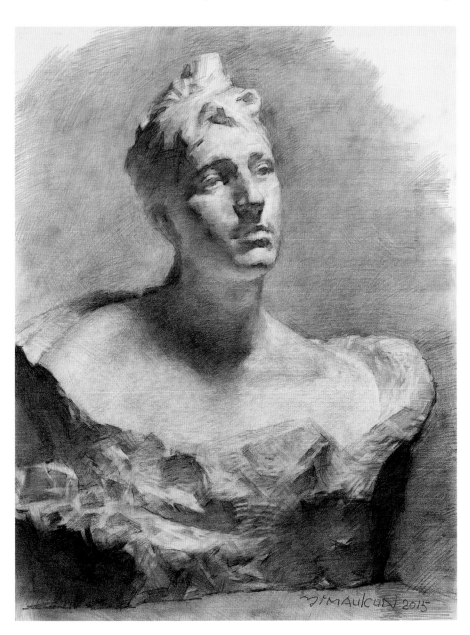

MADAME VICUNA
Pencil on drawing paper, 26½" × 20½" (67cm × 52cm), 2015

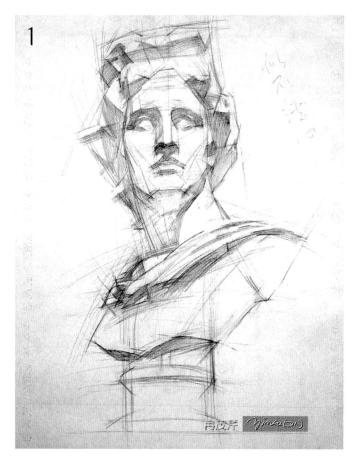

1

This drawing is a teaching demonstration. It's a good example of how I seek to build not only the shape but also volume during the block-in stage.

1. Construct the classical bust on paper using straight lines and conduct planar analysis. Hatch the dark areas using gray. Using gray for dark areas at this point facilitates revisions. We can reinforce or eliminate any parts later easily.

2. Based on the dividing line of the dark and light, reinforce the dark areas and the light areas.

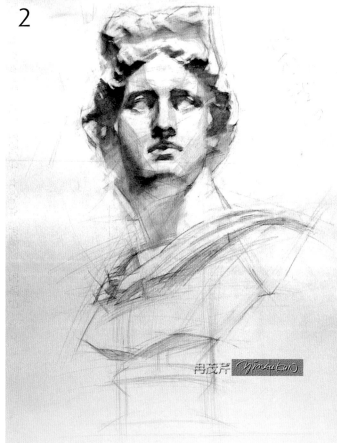

2

3

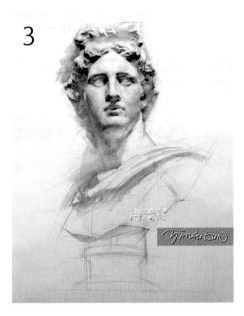

4

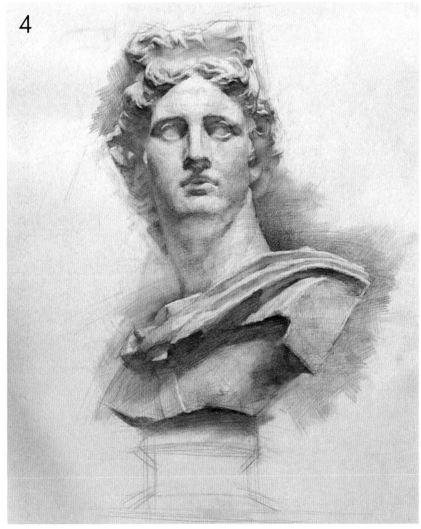

3. Create details by creating different levels of value. Create another three layers of value in dark, middle and light values respectively. In other words, in the dark value, you need to see and create dark, middle and light value within the dark value. The same goes for the middle and light values.

4. At this point, the drawing is almost done. Finish the base of the bust and add the backdrop. When it comes to the backdrop, it may or may not fill the paper. If the backdrop fills the paper, it creates a sense of space. If it doesn't fill the paper, it creates a sense of rhythm.

APOLLO
Pencil on drawing paper, 23¼" × 18½" (59cm × 47cm), 2003

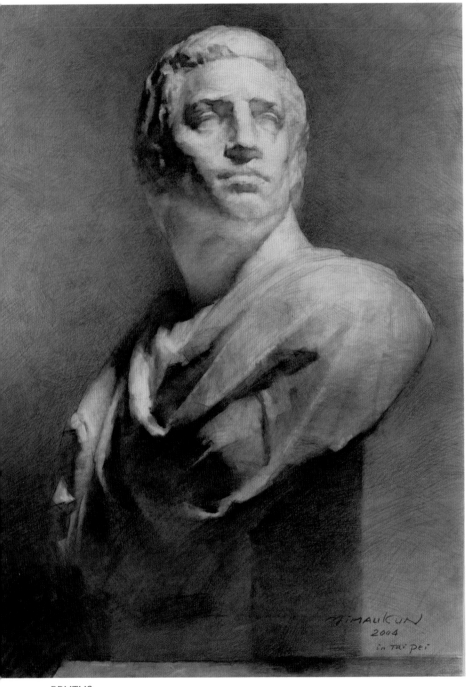

BRUTUS
Charcoal pencil on drawing paper, 28¾" × 21¾" (73cm × 55cm), 2004

I was frustrated by the reflection of dark value created by drawing in pencil and decided to give charcoal pencil a try. I tried charcoal pencil on different kinds of paper and decided on drawing paper, which is solid and has a smooth surface.

In this drawing, I put an emphasis on planar analysis and reinforced some edges of these planes.

This drawing took twelve hours, which is half the time the same drawing took me when I was in the Affiliated High School of Guangzhou Fine Arts Academy.

In 1978, after the Cultural Revolution, I visited alumni at the Guangzhou Fine Arts Academy. I ran into a retired art professor in the school. He asked me, "Mau-Kun Yim, you were the President of Academic Affairs of the Student Association. Do you have any theories why your class has so many outstanding graduates?" (There were more than ten renowned artists from my class.) I replied, "Maybe it was because there was no education reform at the time, and we spent a solid four years on classical bust studies?"

Eugène Delacroix of the nineteenth century said he had never stopped classical bust studies all his life. It's something hard to emulate nowadays for many artists. However, I have been doing classical bust studies since my high school days, and I'm still passionate about them. This is something to be treasured and of which I am proud.

This is a demonstration from my Hong Kong teaching studio. The purpose was to demonstrate the characteristics of light, shadow and values and how different values manifest themselves on a classical bust.

Ever since I started teaching in my Hong Kong studio, I have had my students begin their training with drawing basic shapes and classical bust studies. This approach has been effective in art education. Most of these students from thirty years ago are educators and studio artists now and use the same methodology in teaching.

To further the dialogue with my students in Hong Kong, I wrote down a thought of the week about painting or drawing on a black board in the studio. One such example was about artistic interpretation: When you draw a head, can you draw every single hair, every single pore on the face? It's impossible, nor is it necessary. It's a dead end if you pursue photorealistic in a realistic drawing or painting. Most beginning artists and even some experienced artists have this misconception. They don't understand that art is an interpretation, with selective details. In other words, don't compete with the camera. Don't be proud of creating a photorealistic painting.

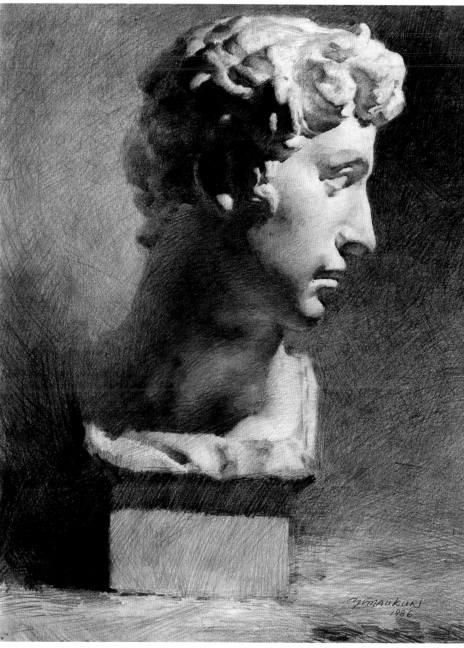

GIOVANNI MEDICI
Pencil on drawing paper, 23¼" × 18½" (59cm × 47cm), 1986

VOLTAIRE

Although there is no backdrop for this classical bust study, I did a comprehensive rendering of the bust. For the parts in the light, I used various styles of hatching to represent the planes. For the dark areas, I emphasized gradation within the dark value.

As a rule of thumb, parts in the light have more hard edges. In the shadow, edges tend to be soft. Variation in value and edges create space and depth. The drawing will appear flat if there is a lack of variation in edge and value. However, there should be some soft edges within areas with hard edges and some hard edges within areas with soft edges.

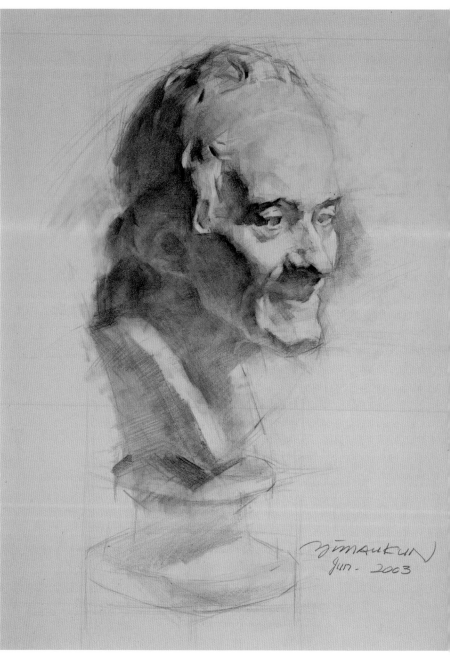

VOLTAIRE
Pencil on drawing paper, 25½" × 19¾" (65cm × 50cm), 2003

BENJAMIN FRANKLIN

This is a demonstration from my teaching studio in Taipei. It illustrates the same subject from different angles in a concise way. The important characteristic of these drawings is constructing the subject and the major planes using straight lines.

When we observe a subject, especially a human being, we feel the subject is composed of contour lines. This is our instinct, and it's not a matter of being right or wrong. However, in my training and practice of realistic drawing, I realized that it's best to begin constructing the subject, especially a human subject, using straight lines to build blocks, planes and facets. Using straight lines enables you to compare length, height, angle and perspectives. You can then compare the size and proportion of the shapes.

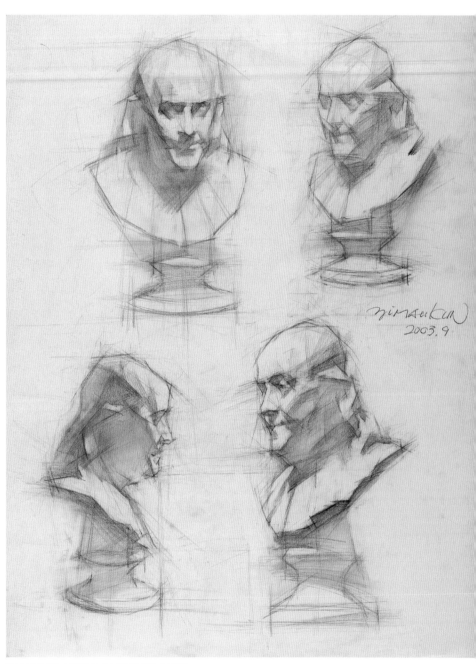

FRANKLIN MULTI-ANGLE STUDIES
Pencil on drawing paper, 23¼" × 18½" (59cm × 47cm), 2003

OLD MAN PLASTER CAST

Doing studies of a small plaster cast bust from different angles is a good exercise prior to transitioning to the live drawing of models and is a must for artists who want to pursue realistic figurative painting. Instead of learning techniques to draw parts here and there, this exercise allows artists to study structure and perspectives of the head holistically.

When you do this kind of exercise, it's best to put all your studies on one piece of paper. You will need to position the three head drawing studies on the paper at the beginning. As you draw, there is no need to go into great detail. The purpose of the exercise is to identify perspectives and the structure of the head from different angles.

STUDIES OF OLD MAN PLASTER CAST
Pencil on drawing paper, 25½" × 19" (65cm × 48cm), 2003

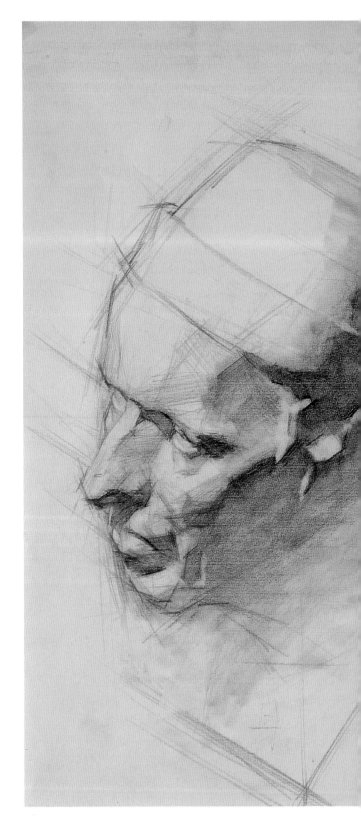

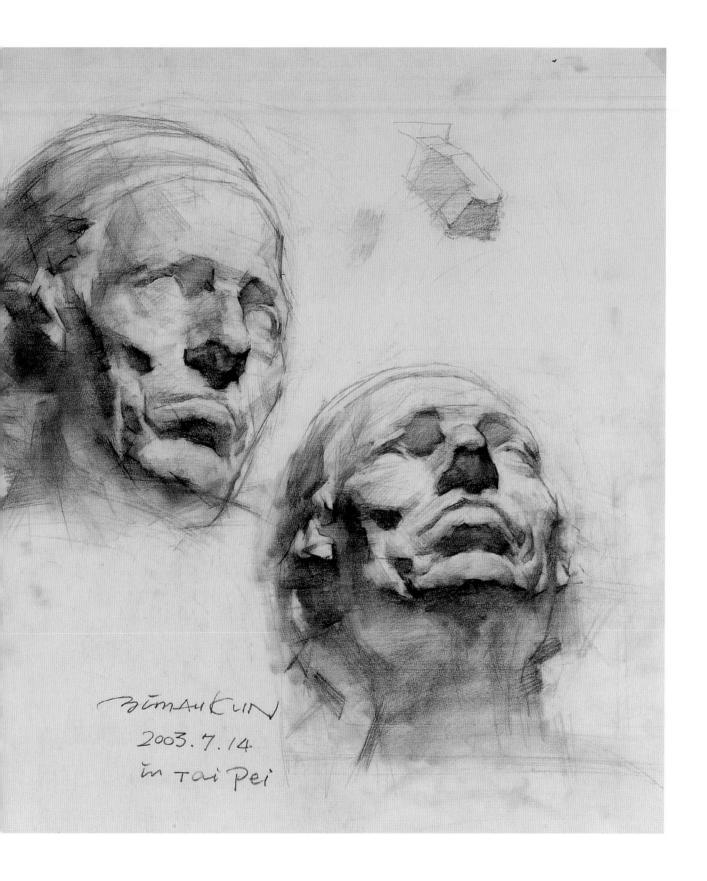

BUMAHKUN
2003. 7. 14.
in Tai Pei

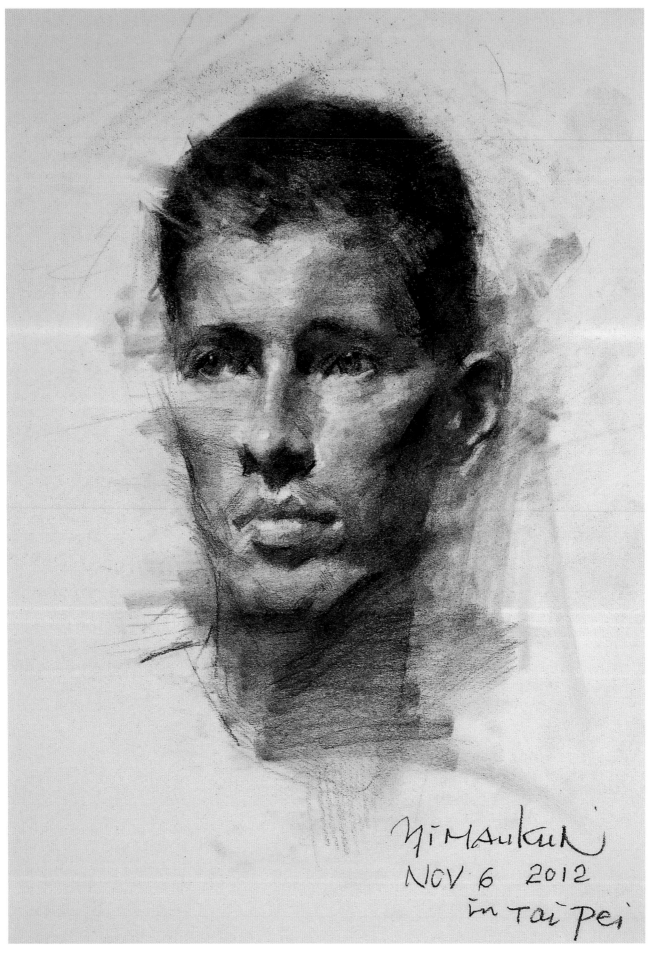

YiMAukun
NOV 6 2012
in Tai Pei

PORTRAIT DEMONSTRATIONS

IN THIS CHAPTER, you will see how the same principles illustrated in the previous two chapters are applied here. We have included process images of drawings of different styles, using different tools such as pencil, charcoal pencil and charcoal. However, you will see that although the principles are the same, the process and techniques may vary slightly depending on the tools and the style of the drawing and the effects I want to achieve. You will also see how pencil, charcoal pencil or charcoal, along with eraser, blender and tissue paper, can create various stroke effects and texture to enrich a drawing.

YOUNG AMERICAN
Charcoal pencil on drawing paper, 24" × 20" (61cm × 51cm), 2012

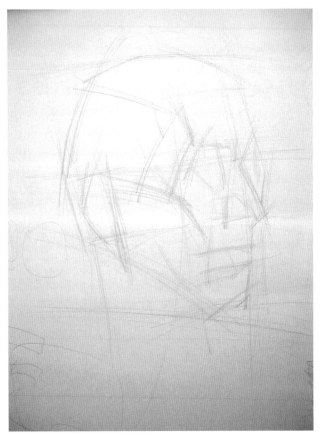

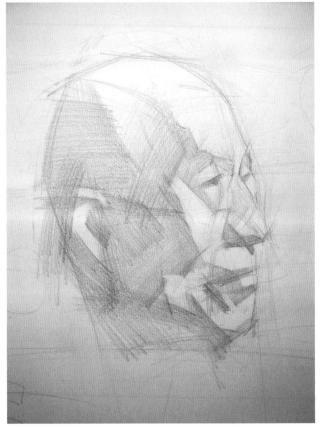

1 *Define boundaries*

Everyone faces the challenge of where to start a head drawing. My approach is to define the upper and lower boundaries by drawing horizontal lines, and then define the left and right boundaries. This is the approximate size of the portrait and its location.

Next, draw the fictional middle line that goes through the nose, and find the cheekbone that is closest to you. From this point, extend above and below to get the two major planes of the head.

Based on the outer boundaries, middle line and the dividing line between the major planes of the head, you can find the line that links the eyes, the line at the bottom of the nose, and the lines for the mouth. Note that the upper point of the ear is at the same height as the eyebrows and the lower point of the ear is at the same height as the base of the nose.

2 *Identify planes*

Dissecting the head into more than a dozen planar zones is a very abstract concept. Constructing a portrait on two-dimensional paper is analogical to sculpting a head except that in drawing you can't actually see these planar zones.

Identifying the planes is a necessary process for realistic figurative drawing. Using straight lines is key to planar analysis.

People often wonder what my secret is. I have jokingly said, "If you can't see the planes, then you need to replace your eyes with mine." Although this is a joke, it also shows my frustration that students are often unable to see the planar zones and put this principle into practice. Although this is a joke, it gets to the importance of seeing the planar zones and putting the principles into practice.

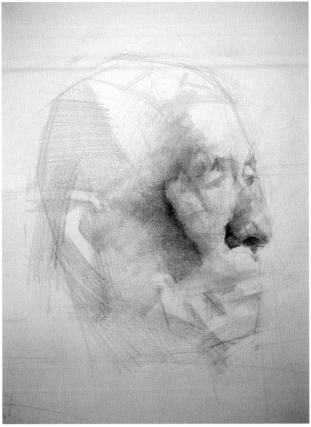

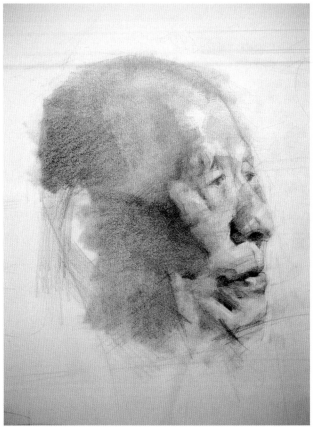

3 *Connect planes and transition to details*

 Next, connect the planes and transition to creating details. I usually start creating details from the nose and then move to the dividing line between the light and dark areas.

 Create details in one small area at a time. Identify and feel the form, gradation and transition between soft and hard edges.

 I used 4B and 5B pencils and cross hatching to connect the different planar zones.

4 *Add details*

 In this stage, work on details of the drawing. Details include facial features, characteristics of bones and muscles and hair. Remember that details include transition in value, space and edges.

 Many artists tend to use contour lines to call out too many details, including eyes and nostrils. I constantly remind my students to not be fastidious. Remember that details include transition in value, space and edges.

 Furthermore, the nostrils are often in the shadow, unless the subject is under strong light. The form is often not clear in shadows. Therefore, it doesn't call for contour lines and hard edges. Details are not just about contour lines, they're also about transition in value, space and edges. Practicing this principle of detail rendering is a key differentiation between professionals and amateurs.

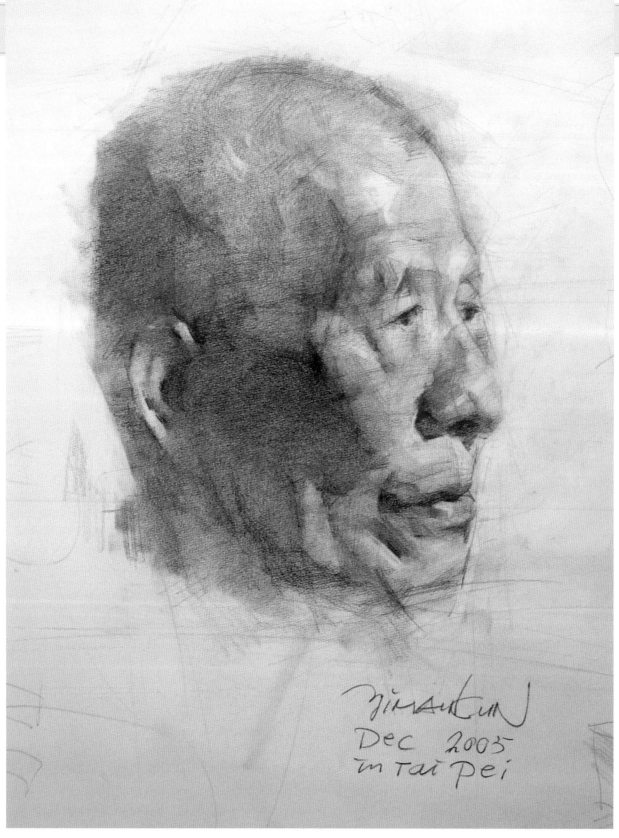

The benefit of drawing in pencil is its versatility. You can render the subject
in broad strokes and also create great detail, particularly when rendering
the psychological state of the subject. Pencil, when combined with an eraser,
can create various stroke effects to enrich the drawing. Pencil drawing is the
foundation of drawing using other tools, and it's an art form in itself.

MR. LEE
Pencil on drawing paper,
19" × 13½" (48cm ×
34cm), 2005

The methodology of creating three-dimensional subjects on two-dimensional paper is to start from planar analysis, then create values starting from the boundaries of planar zones, between light and dark, and, finally, create details.

This piece illustrates the process of drawing in one glance.

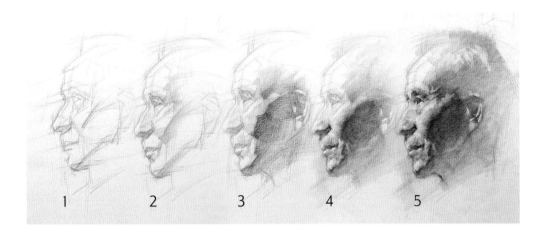

1. Use a B pencil to define the boundaries and outline the head.

2. Next, identify the marked the boundaries of the planar zones of the forehead, nose, cheekbones and lower jaw.

3. Switch to a 3B or 4B pencil to add value to the dark areas and further refine the middle tone areas.

4. In the final stages, create details. Many artists start with facial parts, such as the eyes, nose, mouth and ears when drawing a head. Even if the artist is talented enough to render these parts in great likeness to the actual parts, the entire drawing will appear flat and two-dimensional.

5. Creating three-dimensional subjects on two-dimensional paper is the result of continuous exploration by artists since the Renaissance. This knowledge of perspectives and light needs to be studied and passed on through generations so that we don't just see the lines, but we also see the effects of the light.

MAN WITH GLASSES

This drawing has an off-the-cuff quality but still includes exquisite details using charcoal pencil, pastel paper and paper blender.

This demonstration was done during the third stop of my 2009 workshop tour in the United States. The drawing was done in artist Ron Lemen's studio in San Diego. The studio was packed during this demonstration. The fact that the windows facing the street were shaded made it feel even more crowded. Nonetheless, I thoroughly enjoyed the lecture and demonstration. A local Chinese resident, Mr. Zhang, served as the interpreter.

My student Ray Seitz lived in San Diego at the time. He drove me around in his yellow SUV and took me to the beach for plein air painting every day. My trip was very productive, and we didn't waste any time or southern California sun!

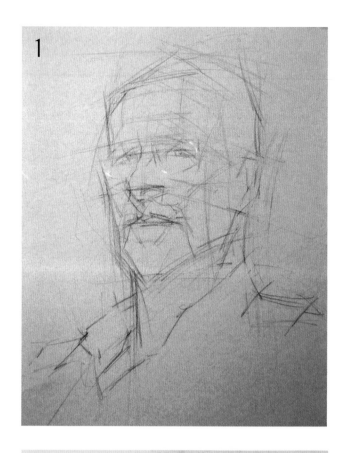

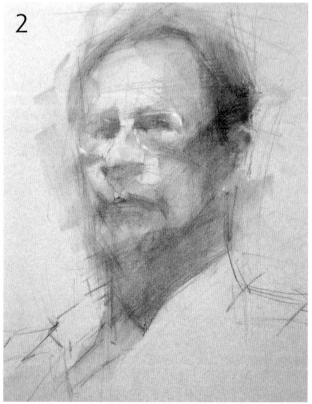

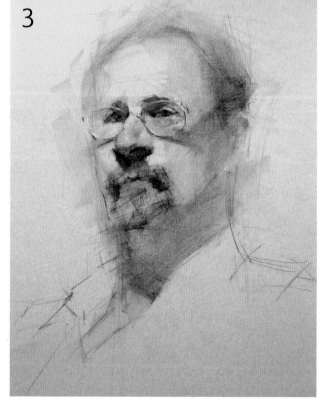

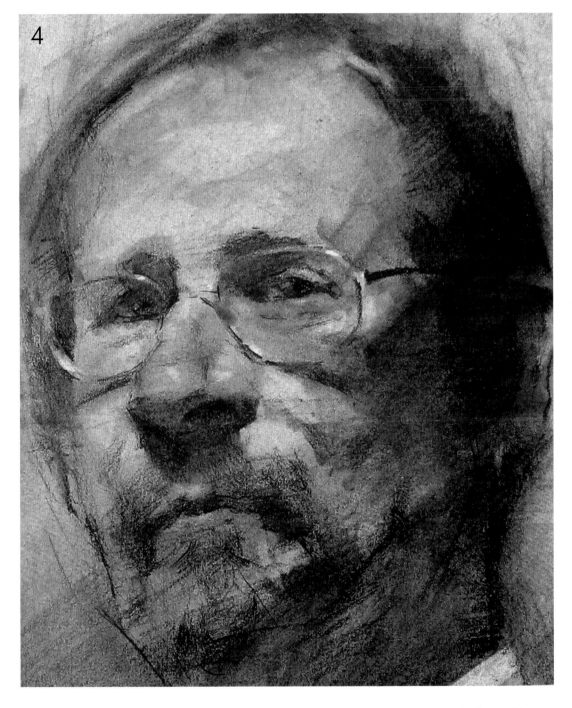

4

MAN WITH
GLASSES
Charcoal pencil on
pastel paper, 21"
× 14½" (53cm ×
37cm), 2009

1. During block-in, create planar analysis of structure, bones, facial parts and value zones.

2. Define the dark value zones.

3. Further define facial parts.

4. Finally, create details for the face. Add strokes and lines; add highlights using a white pencil and effects using a paper blender. Create nuances in middle value, dark value and edges.

1

2

3

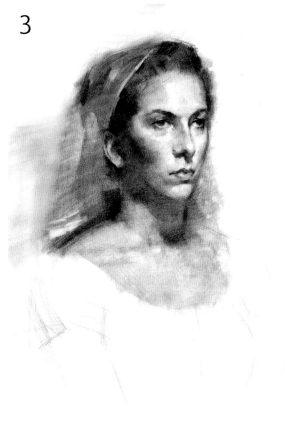

4

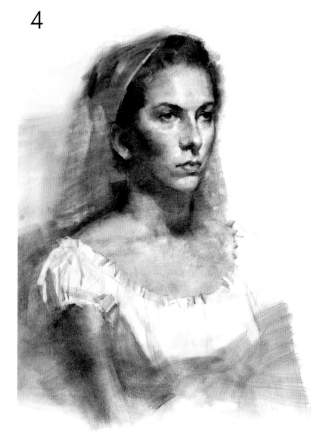

In this drawing, I used the pencil to create details with lines and represented the soft texture of the skin with a paper blender.

1. The first step of block-in for this head and shoulder portrait is to decide the size and location of it.

 Next, identify the perspectives of the shoulders and chest. The neck is a cylinder and key to connecting the head and chest.

2. Identify the locations of the facial features, especially the three planar zones of the nose. The nose needs to be erected as in a sculpture. Using the nose as a benchmark, locate the forehead, cheekbones, maxilla and mandible.

3. Allocate eighty to ninety percent of the time you spend on a head and shoulder portrait focusing on the head and face.

4. You can be more flexible with the clothes and backdrop because they can be rendered in a more impressionistic or realistic style, depending on the effects you want to create.

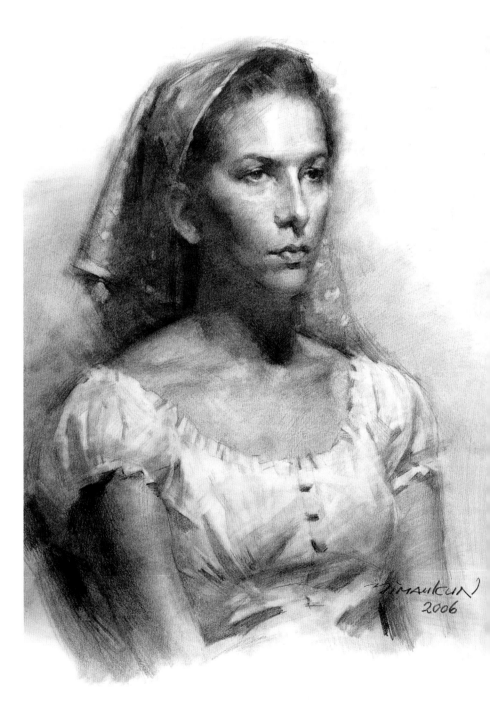

HANA
Pencil on drawing paper, 25" × 19" (64cm × 48cm), 2006

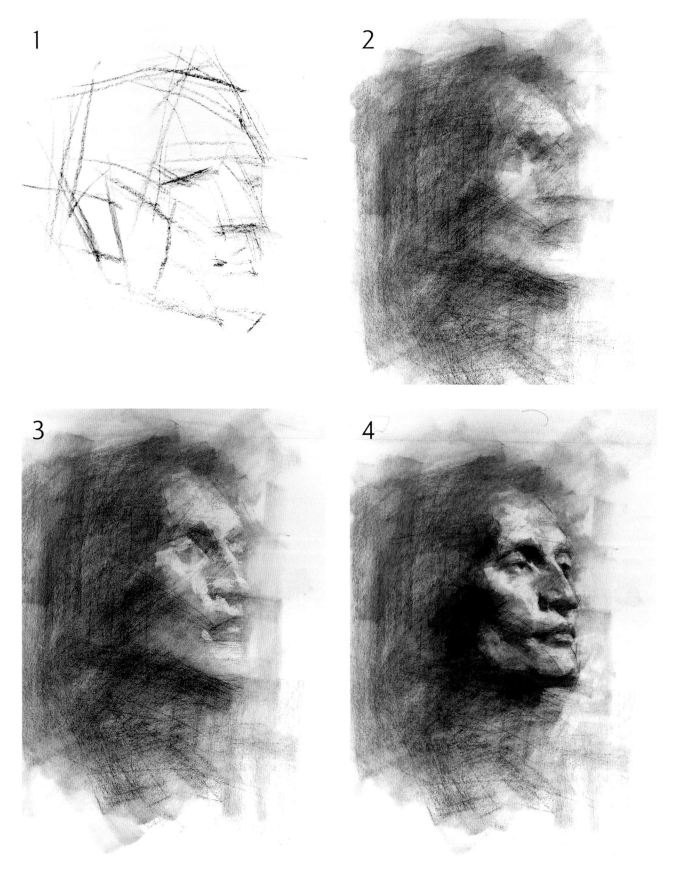

I used a unique approach for this drawing. Instead of my usual process of building a fairly tangible structure of the drawing during block-in, I defined the approximate area for the head and used an approach similar to sculpture to "carve" out the head gradually. I first defined the key blocks, then identified the forehead, cheek bones, and the chin, and then created details. You will notice that no lines are used in this drawing other than the initial stage. This approach creates a realistic yet artistic and interesting drawing.

1. Define the planar zones using charcoal.

2. Define the large planes of dark areas with charcoal.

3. Use a rubber eraser to define the light areas.

4. Create details for the facial features.

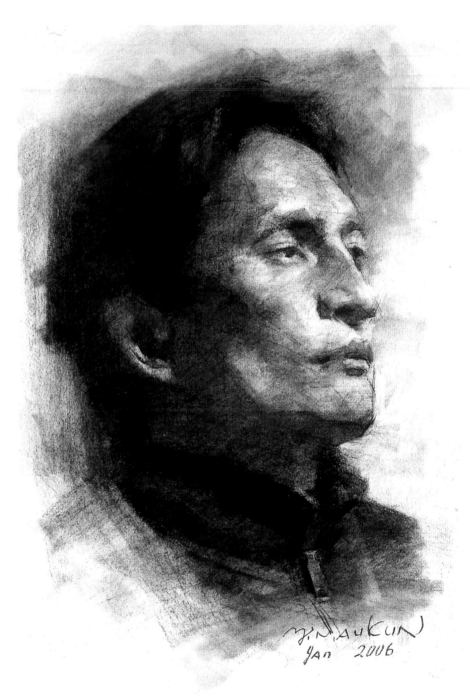

ATAYAL YOUTH
Charcoal and charcoal pencil on pastel paper, 16½" × 12" (42cm × 31cm), 2006

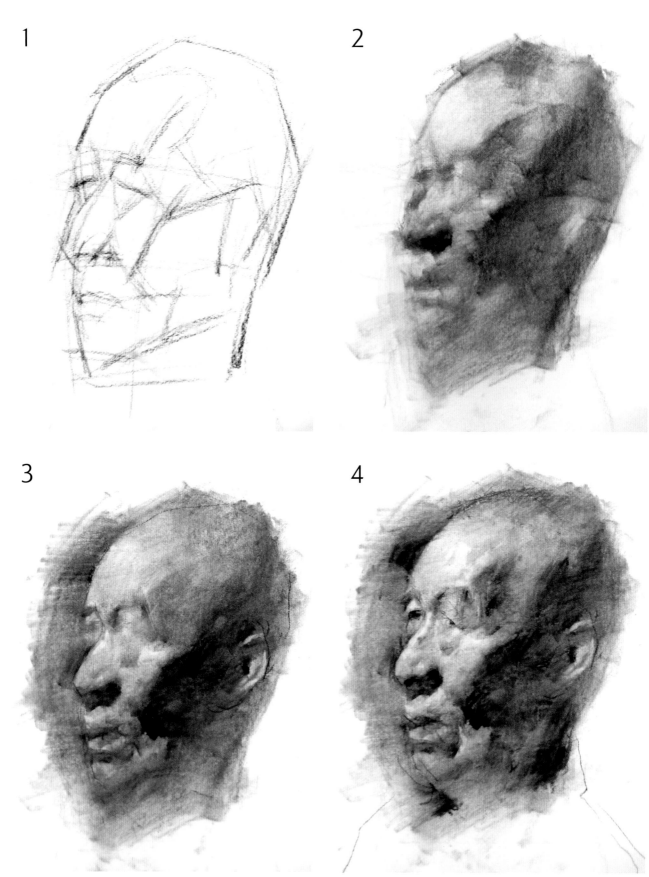

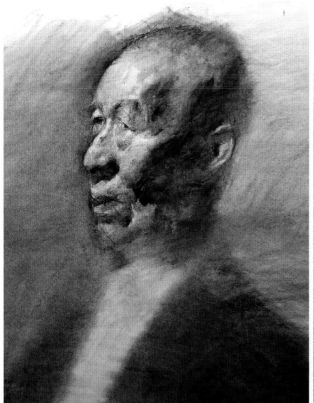

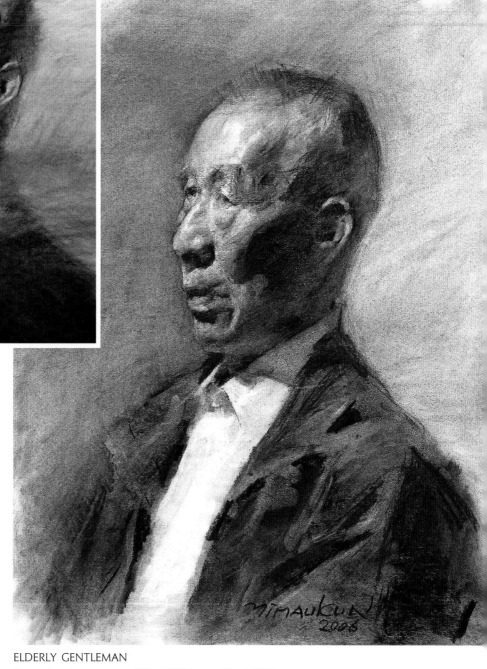

This drawing has the characteristics of an oil painting. It has precise details but also a relaxed and off-the-cuff quality.

1. First, build the structure of the head.

2. Shade the dark areas then add middle value.

3. Identify and reinforce the light areas of the head to finish the rough sculpture of the head.

4. During the stage of creating details, feel the surface of the form like a sculptor and create the details you feel with nuances in value and edges to convey the spirit of this eighty-something-year-old man.

ELDERLY GENTLEMAN
Charcoal on drawing paper, 25" × 19" (64cm × 48cm), 2006

81

MICHAEL

This style of charcoal pencil drawing on pastel paper is what I call line drawing. This drawing approach draws on inspirations from Hans Holbein der Jüngere, Nicolai Ivanovich Fechin, and Chinese traditional ink paintings. It has a rather relaxed and off-the-cuff quality, but it is expressive, with every stroke hitting its mark.

The lines are edges of the form and boundaries between the light and dark areas; they also make the bones stand out. After the lines are drawn, use a blender to soften the lines to create a sense of three dimensions and multiple layers.

When creating this type of drawing, don't use pastel paper that is too dark, and don't overuse the white pencil; apply it only to the eyeball and the highlight of the nose.

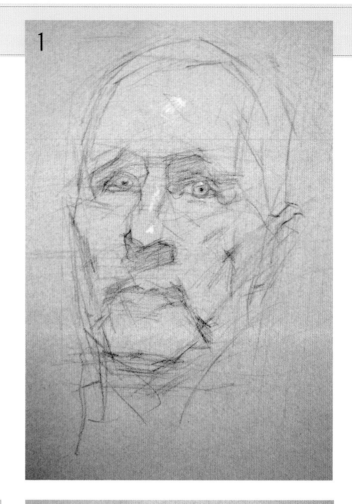

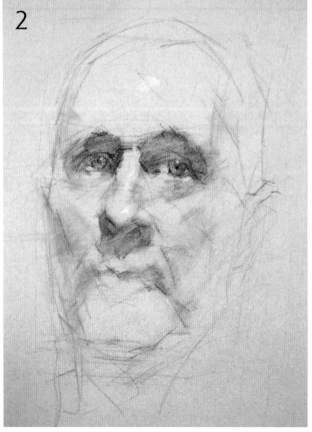

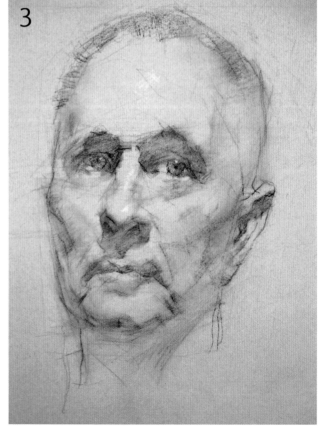

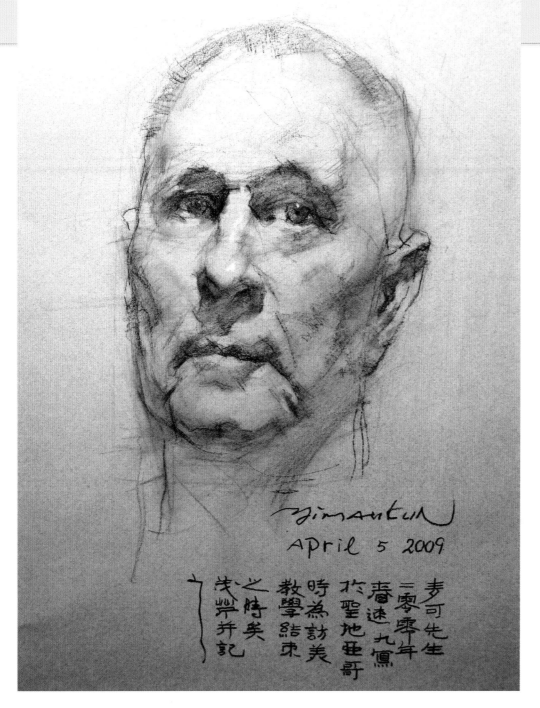

MICHAEL
Charcoal pencil and
white pencil on pastel
paper, 21" ×14½"
(53cm × 37cm), 2009

1. Build the structure of the head using straight lines. The lines are edges of the form and boundaries between the light and dark areas.

2. After the lines are drawn, use a blender to soften the lines to create a sense of three dimensions and multiple layers. Further define dark areas such as the eyes and the bottom of the nose.

3. Create details using the same process—adding lines and softening of lines.

ABOUT THE MODEL

Michael joined the navy when he was younger. He hurt his spine during a dive and has been paralyzed since. He switched careers, graduated from a MFA program and has been making a living as an artist. I drew this head portrait full of respect for this gentleman.

YOUNG AMERICAN

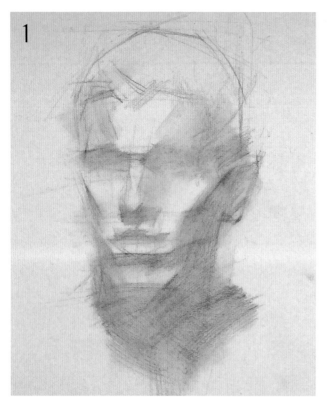

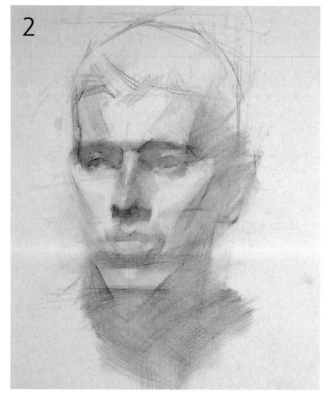

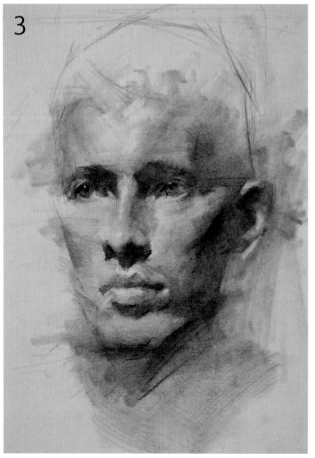

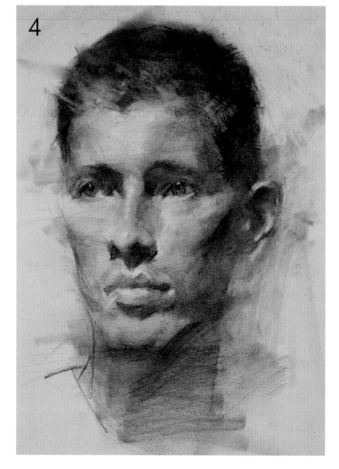

This drawing is a good example of my methodology and principles:

1. Start from planar analysis.

2. Build out the form using light, middle and dark values.

3. Work on the entire head during each step to keep everything consistent, and create strokes, values and edges along the way.

4. Re-examine the entire drawing, reinforce the forehead to make it stand out a little bit more. Reinforce the nose as well and the highlight of the eyes.

A drawing needs to have strokes, whether you're using a pencil, charcoal pencil or charcoal. Without strokes the result is overly smooth, similar to a photo. The underlying reason for such a style is the lack of classical bust study and planar analysis training necessary in order to create and construct a three-dimensional subject on paper.

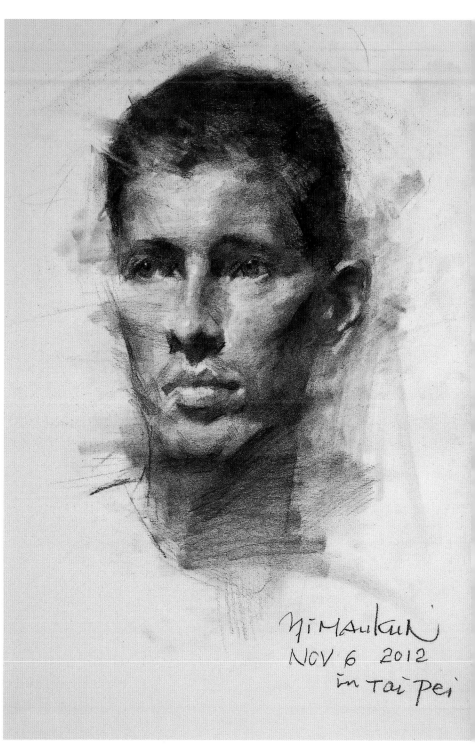

YOUNG AMERICAN
Charcoal pencil on drawing paper, 24" × 20" (61cm × 51cm), 2012

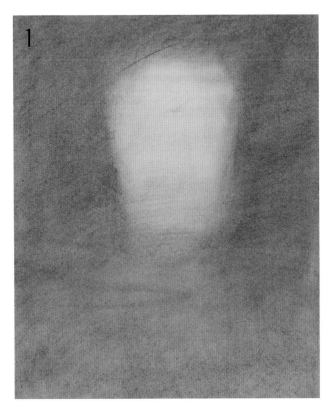

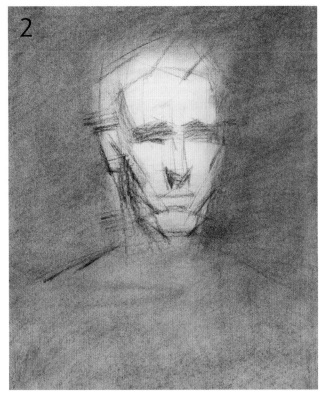

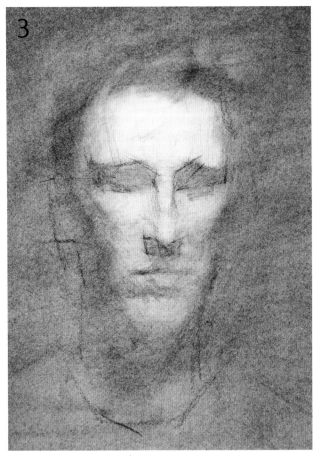

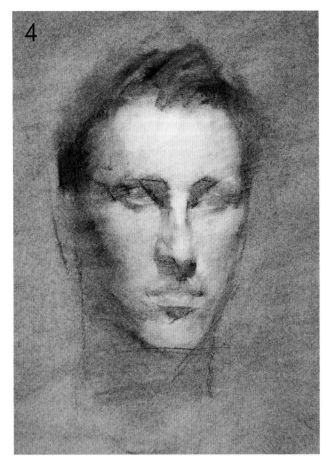

After we settled on the pose of the model, it occurred to me to create a drawing similar to a classical oil painting. To achieve this look, I simplified the backdrop and clothes. I drew the head so it is immersed in the space, yet stands out in front of the backdrop. As the viewer looks at the drawing, the focus finally falls on the eyes and nose.

This approach is different than my usual drawing process.

1. Work on the backdrop first after blocking the location of the head, reversing the order of my usual process. The benefit of this approach is the harmonious relationship between the subject and the backdrop and the sense of air flowing in the space.

2. Build the structure of the head.

3. Shade the dark areas and then add middle value.

4. Further define features and middle value. Create details, and reinforce the forehead and nose with highlights.

This is an interesting experiment, and the resulting drawing reminds me of the work of Titian during the Renaissance.

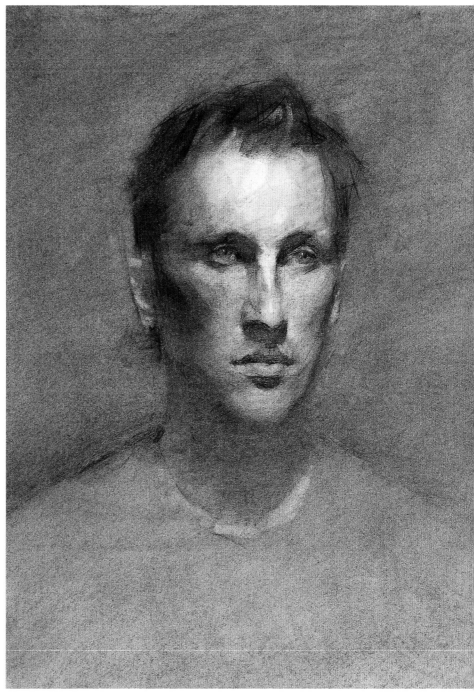

YOUNG RUSSIAN
Charcoal on drawing paper, 24" × 18" (61cm × 20cm), 2006

ERHU MUSICIAN

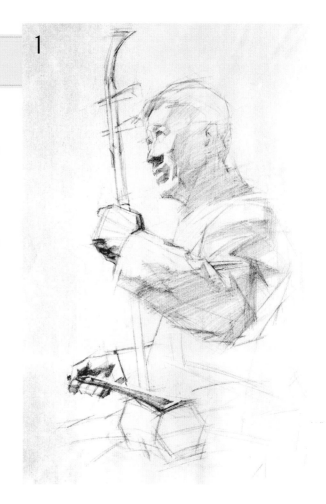

Since this is a teaching demonstration, I took a very rigorous approach to ensure that the drawing accurately captured the form, the pose and the sitter's personality.

The most challenging part of this drawing is the dark cotton jacket. To render the jacket, I first hatched the entire area and then created value and wrinkles. I took great care to render the details of the jacket and the instrument to convey a sense of depth of the subject.

1. Build the structure of the drawing.

2. Add value to key blocks.

3. Further define each part.

4. Create details.

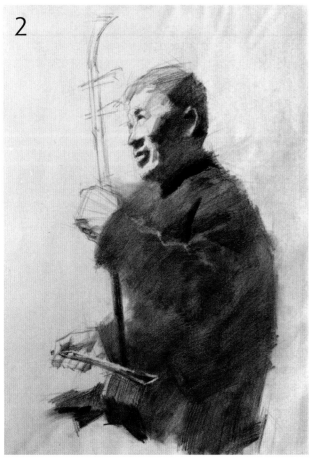

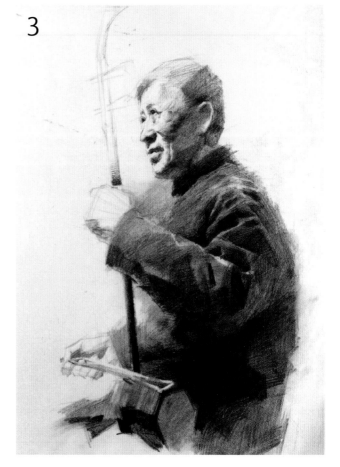

4

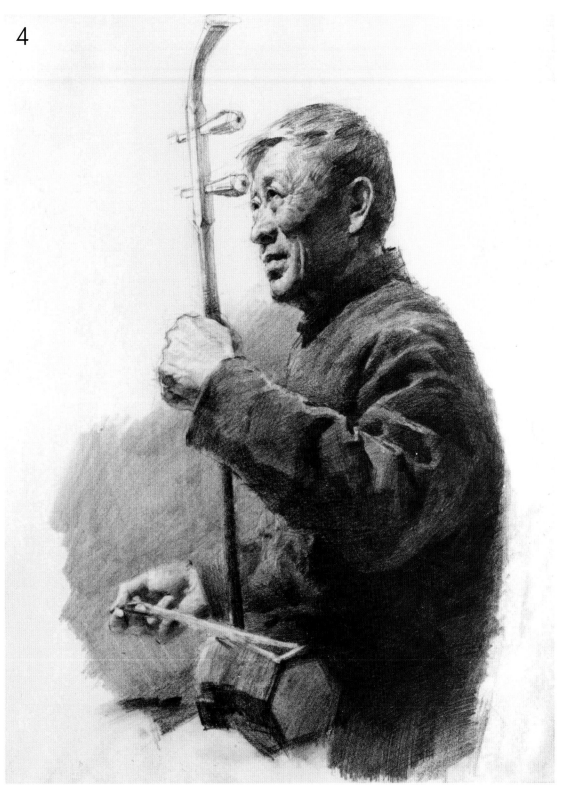

ERHU MUSICIAN
Pencil on drawing paper, 25½" × 19½" (65cm × 50cm), 2000

1

2

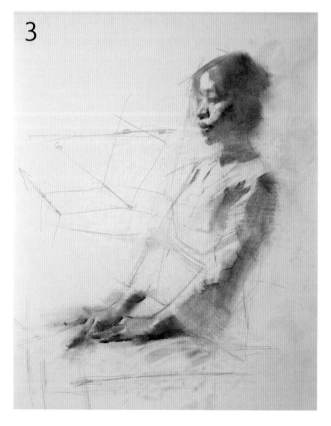

3

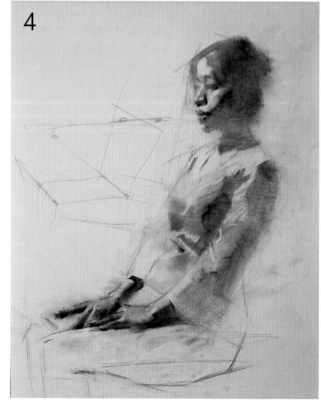

4

This is a demonstration I created in my teaching studio in Taipei. I used hatching and cross-hatching for the head, clothes and the hands to convey the spirit and energy of this dance teacher so that the drawing has a sense of music and rhythm to it.

Additionally, in order to demonstrate the application of perspectives in this drawing, I used horizontal lines to connect the shoulders, hips and knees. Correct proportions and perspectives are key to drawing portraits that include the body.

1. Build the structure including perspective and proportion.

2. Add value to key blocks starting from the head.

3. Continue to add value to the body and hands.

4. Further define the head, body and hands.

5. Create details.

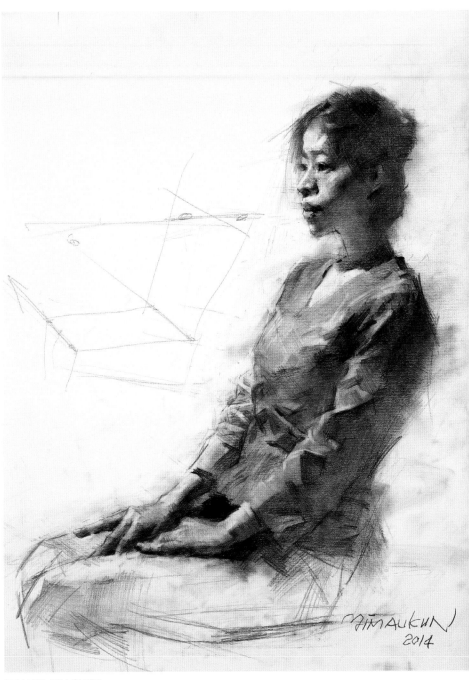

DANCE TEACHER
Pencil on drawing paper, 24" × 20" (61cm) × (51cm), 2014

TANYA

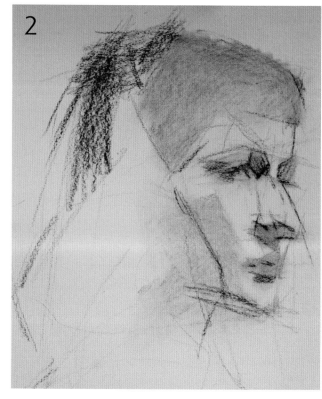

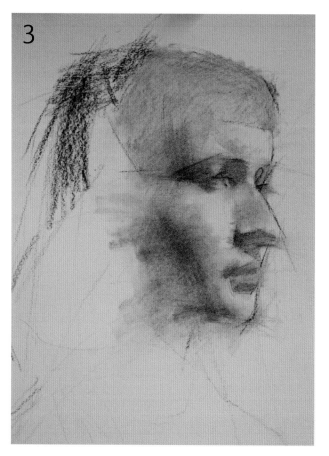

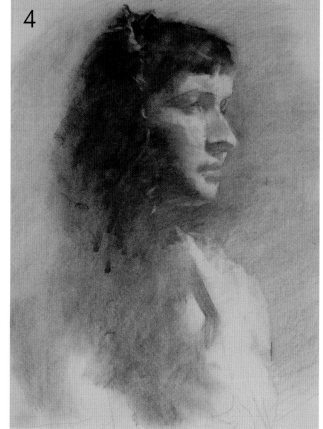

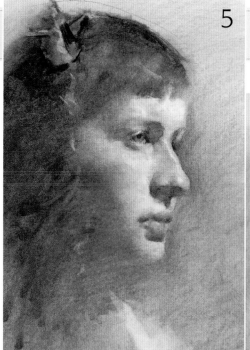

5

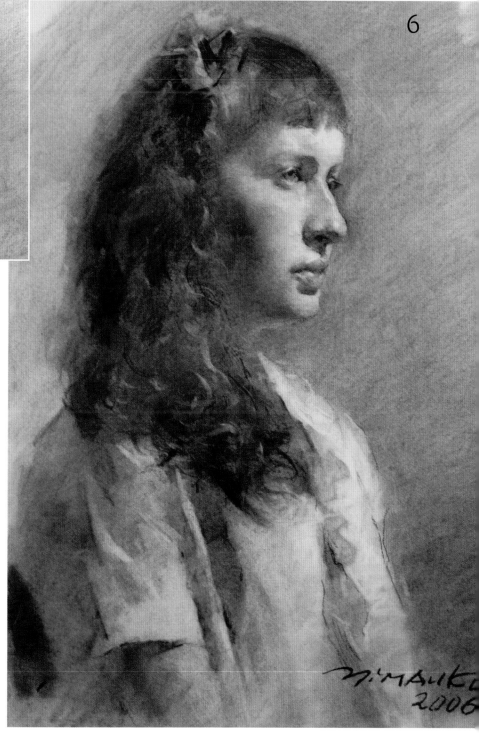

6

This type of head and shoulder portrait with full backdrop is very helpful when transitioning from drawing to oil painting, when one has to fill the entire canvas. The greatest challenge when creating the drawing is the handling of the delicate relationship between the subject and the backdrop. The backdrop needs to be solid yet allow air to flow in the space at the same time. Another challenge is creating a middle value using charcoal. Charcoal powder falls off easily, and it's very difficult to create the precise value that you want. It takes a lot of practice and trial and error.

When it came to details, I used a blender made of rice paper to create the texture of her rosy cheeks, the middle value of the nose wall shadow, and her full lips.

1. Block in.

2. Planar analysis.

3. Add value.

4. Further define the dark areas and add backdrop.

5. Add details and create highlights.

TANYA
Charcoal on drawing paper, 23½" × 18"
(60cm × 48cm), 2006

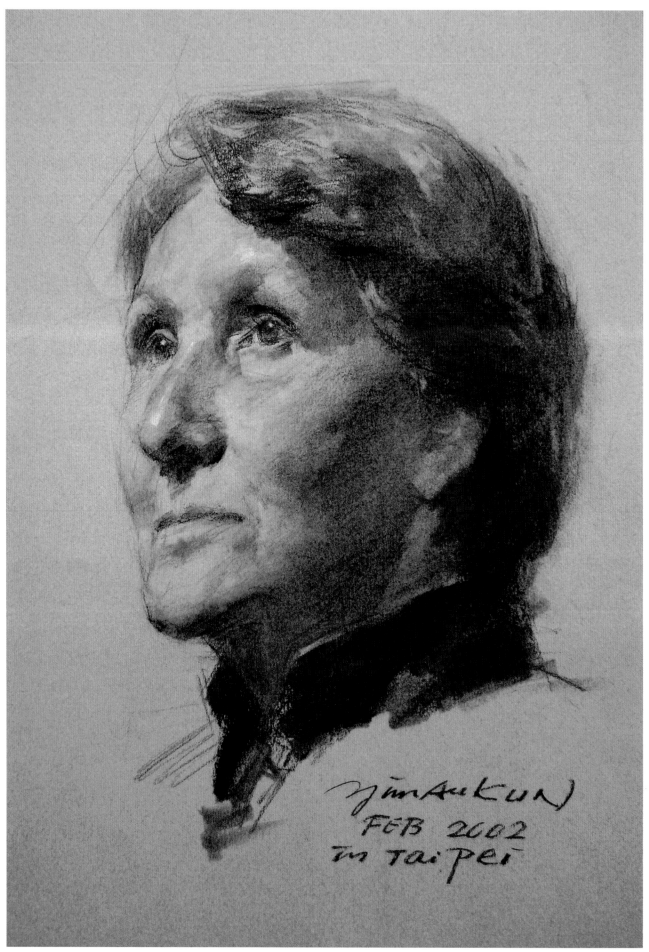

GALLERY OF DRAWINGS

THE GALLERY PRESENTS drawings in different categories such as classical bust study, sketch, portrait, using various tools (pencil, charcoal pencil, charcoal) to illustrate how the principles and techniques in previous chapters can be applied to life drawing in different ways. There are many different ways to draw the head to convey the subject's spirits and create a certain mood or ambiance in the drawing after you master the basics—using straight lines to block in, planar analysis, value, classical bust study and anatomical study. And I hope you will agree with me, drawing can be fun, creative, artistic and aesthetic.

Some of the portraits are head and shoulder, half-lengths or three-quarters portraits. They are examples of how I handle the clothes, hands, the sitter's position and the background. After you master drawing the head, you can move on to drawing more than the head in a portrait.

AMERICAN WOMAN
Pencil on paper, 24" × 20" (61cm × 51cm), 2001

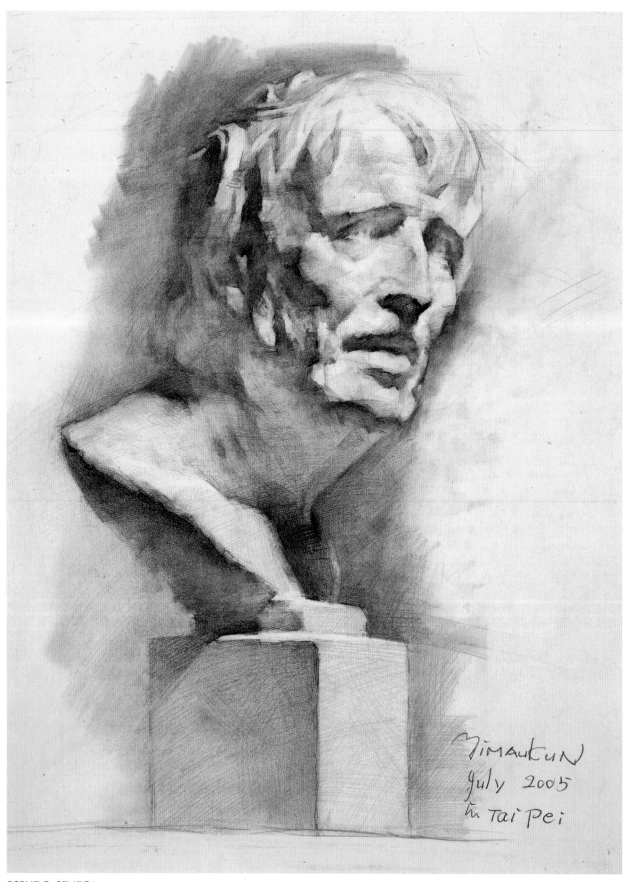

PSEUDO SENECA
Pencil on drawing paper, 23¼" × 18½" (59cm × 47cm), 2005

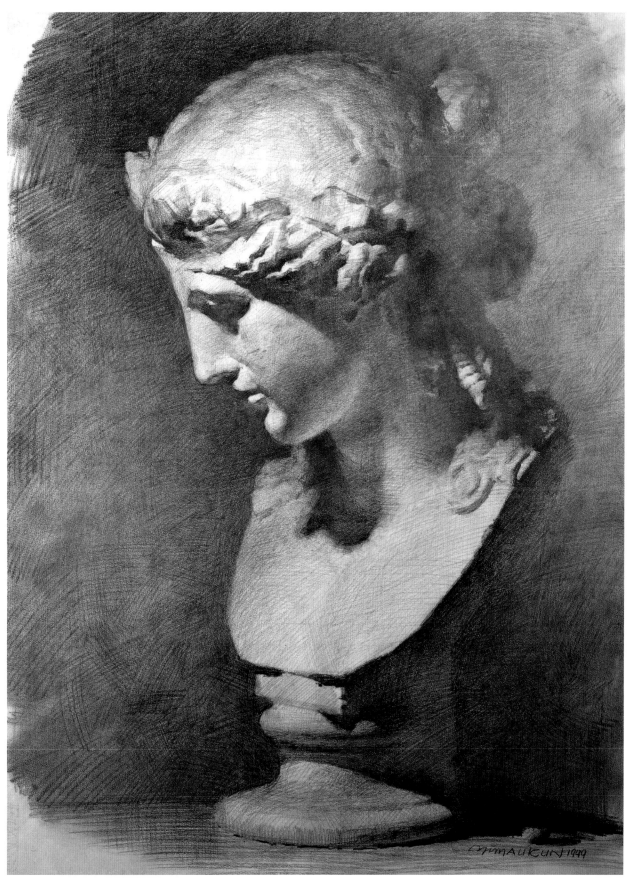

ARIADNE
Pencil on drawing paper, 24½" × 18½" (62cm × 47cm), 1999

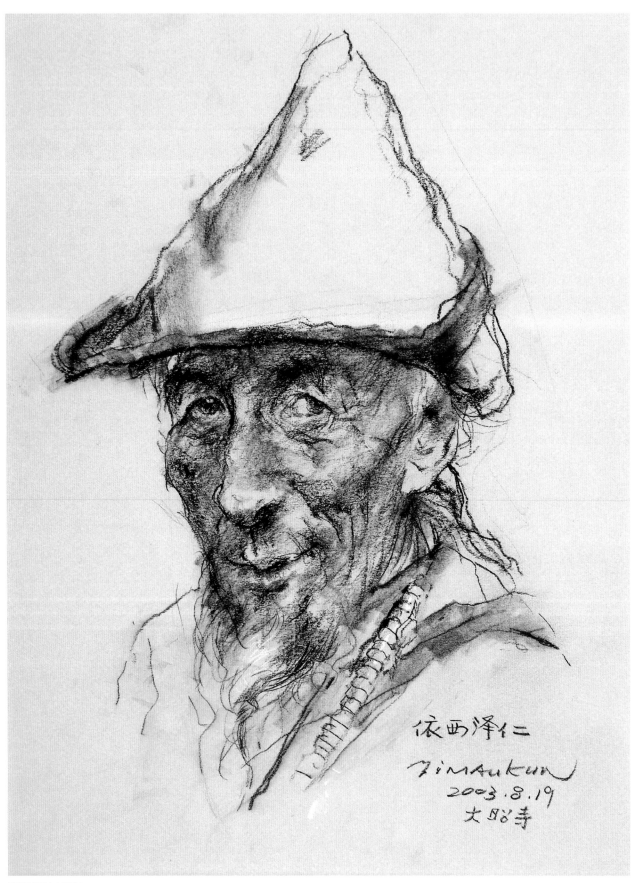

TIBETAN MAN
Charcoal pencil on paper, 16½" × 11¾" (42cm × 30cm), 2003

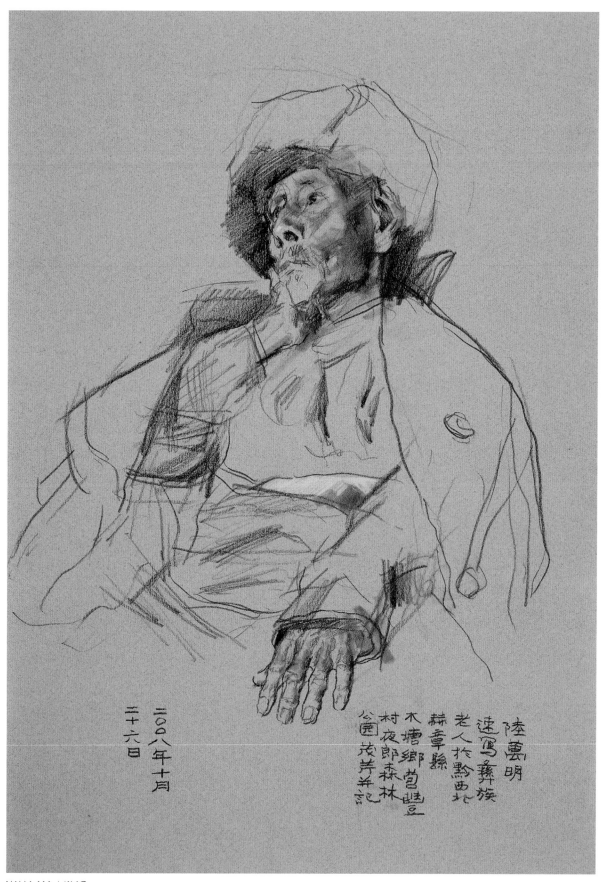

陸雲明
速寫彝族
老人於黔西北
赫章縣營盤
木塘鄉森林
村夜郎森林
公園茂芹芹記

二〇〇八年十月
二十六日

WAN LU-MING
Pencil sketch, 20½" × 14¼" (52cm × 36cm), 2008

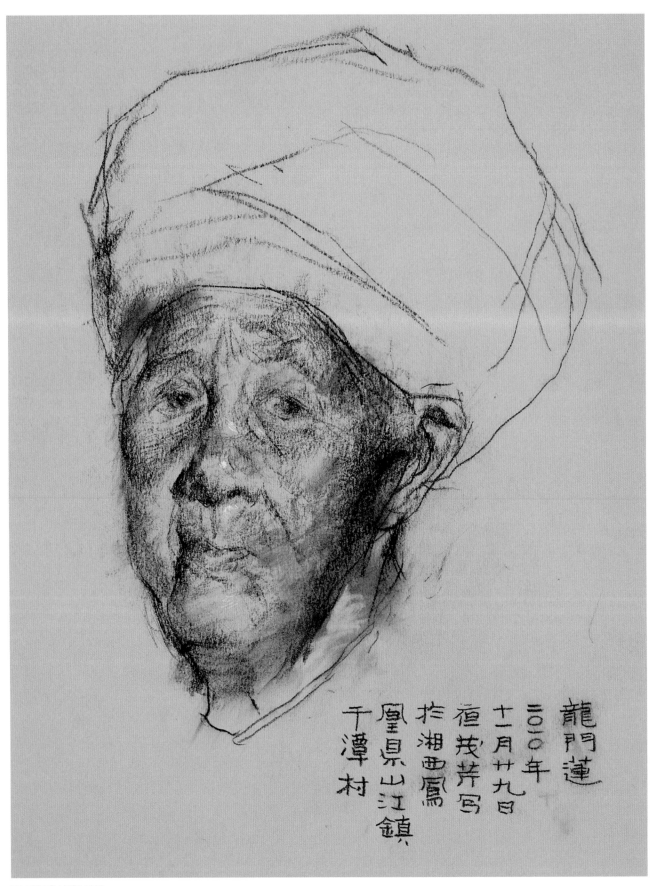

龍門蓮
二〇一〇年
十一月廿九日
恒茂芹寫
扵湘西鳳
凰県山江鎮
干潭村

HMONG WOMAN
Pencil on paper, 13" × 15¼" (33cm × 39cm), 2010

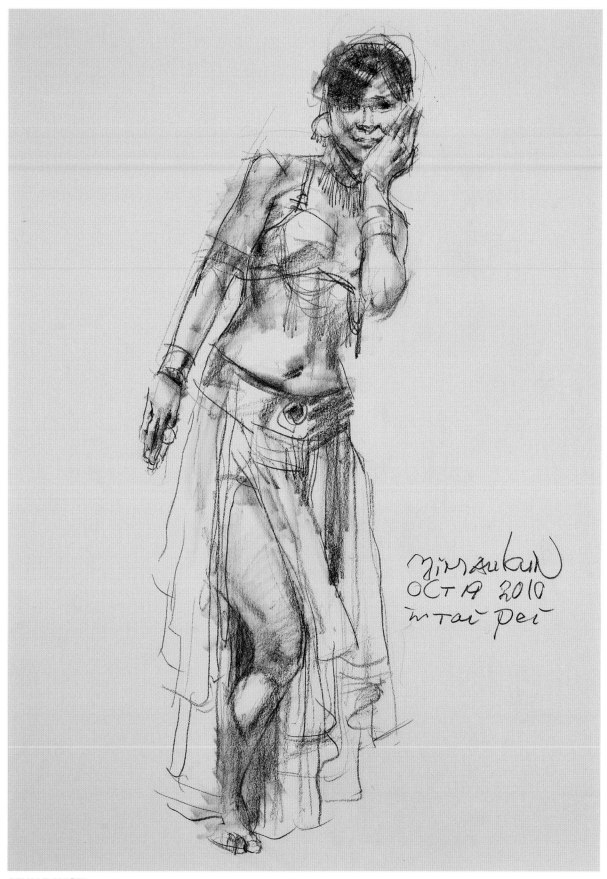

BELLY DANCER
Charcoal pencil on paper, 14" × 20¼" (36cm × 51cm), 2010

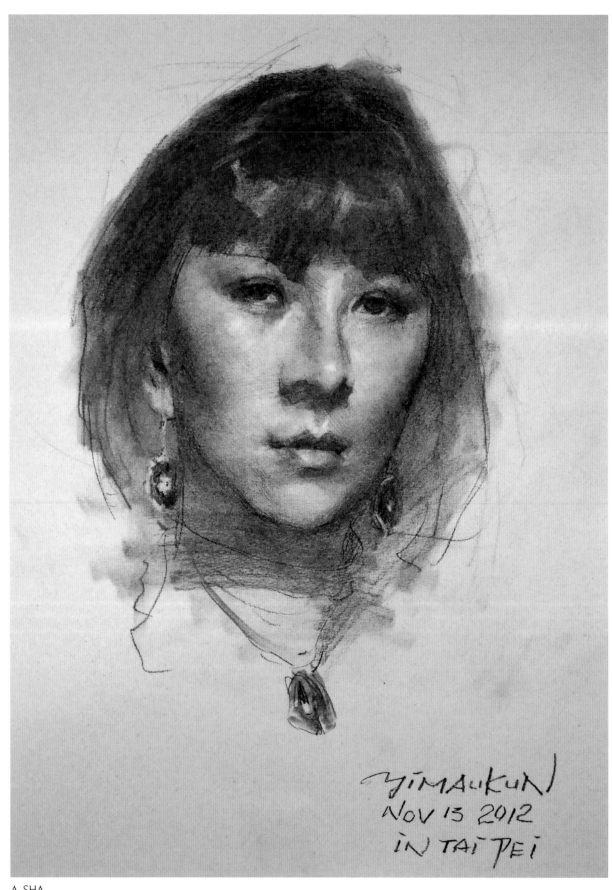

A SHA
Charcoal pencil on paper, 23¾" × 19½" (60cm × 50cm), 2012

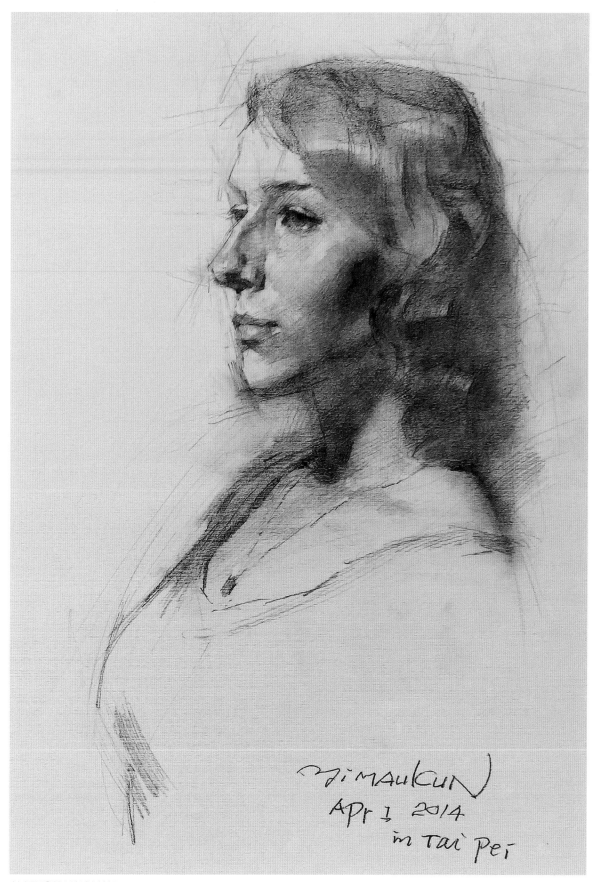

AMERICAN WOMAN
Pencil on paper, 23¾" × 19½" (60cm × 50cm), 2014

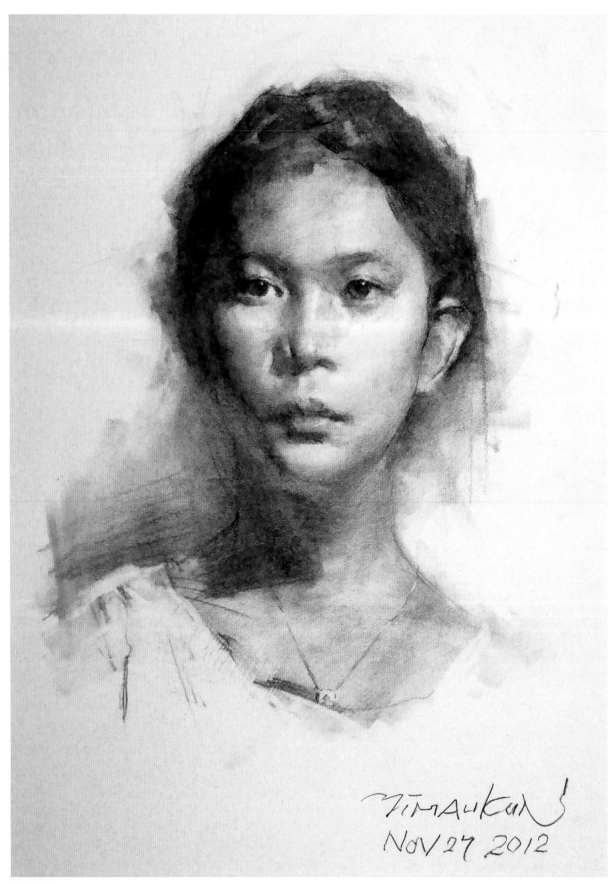

FILIPINA
Pencil on paper, 23¾" × 19½" (60cm × 50cm), 2012

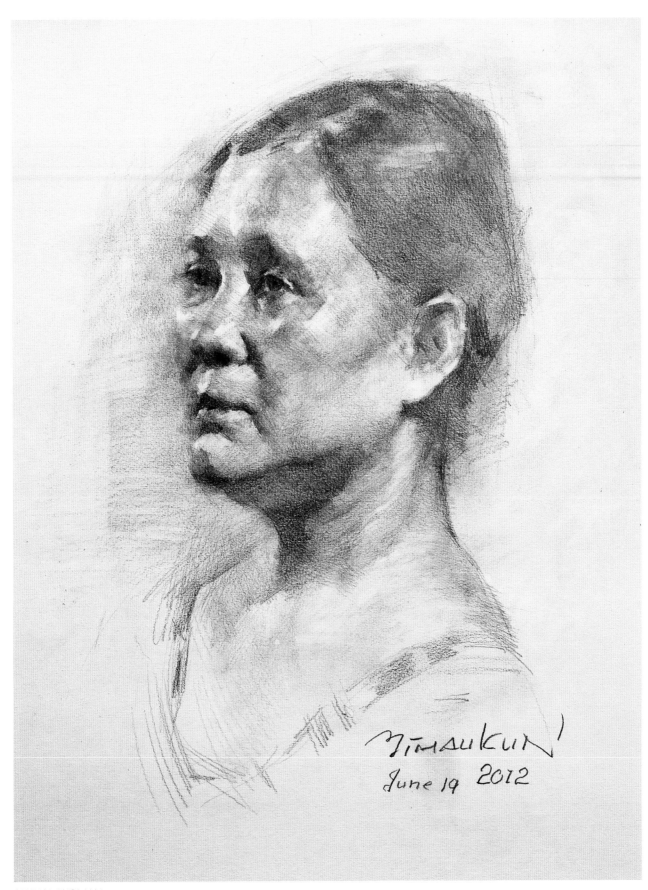

ATAYAL WOMAN
Pencil on paper, 23¾" × 19½" (60cm × 50cm), 2012

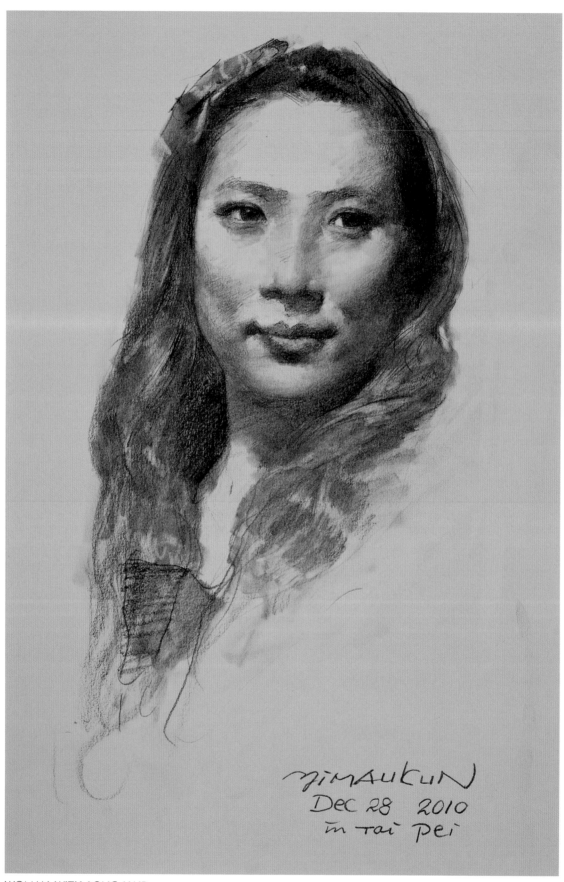

WOMAN WITH LONG HAIR
Charcoal pencil on paper, 19¼" × 12½" (49cm × 32cm), 2010

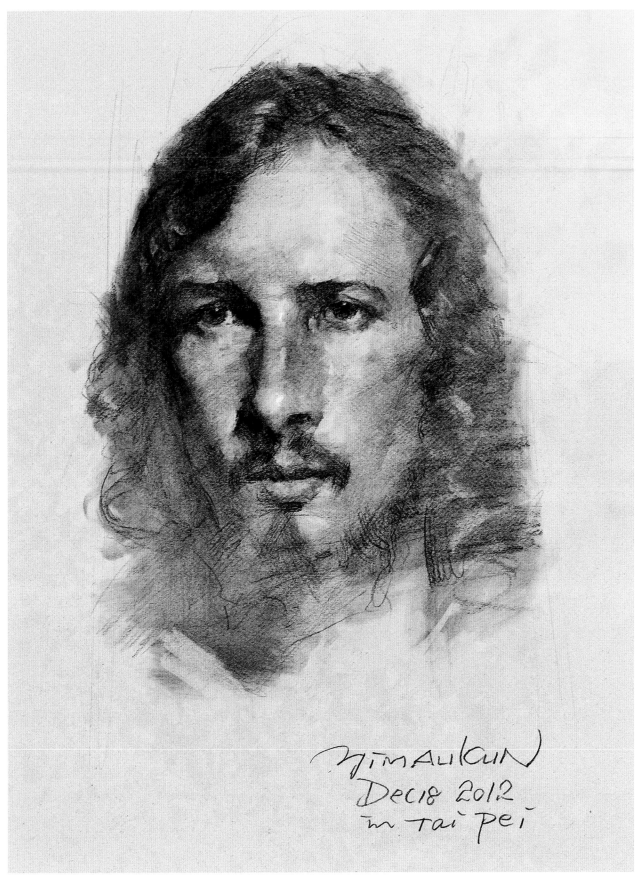

YOUNG GERMAN
Charcoal pencil on paper, 23¾" × 19½" (60cm × 50cm), 2012

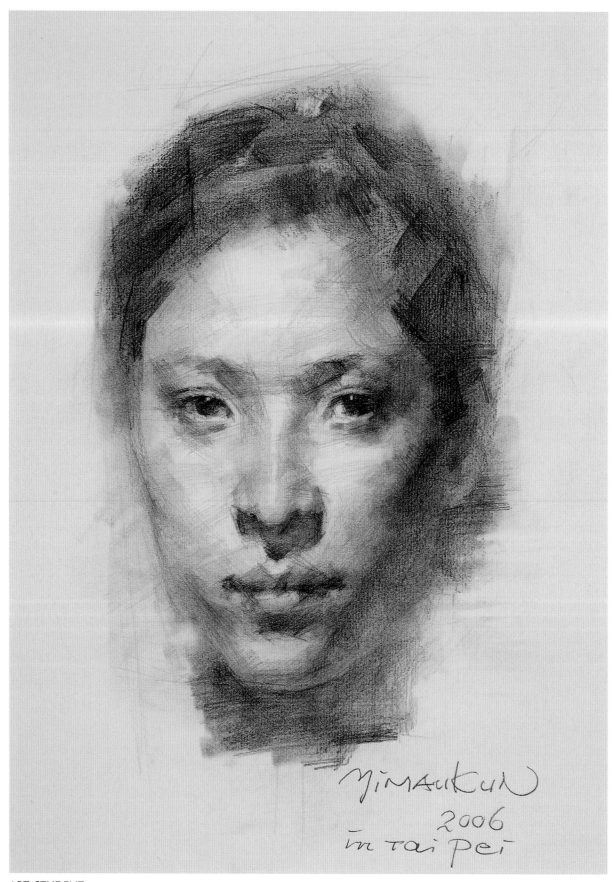

ART STUDENT
Pencil on paper, 16½" × 11¾" (42cm × 30cm), 2006

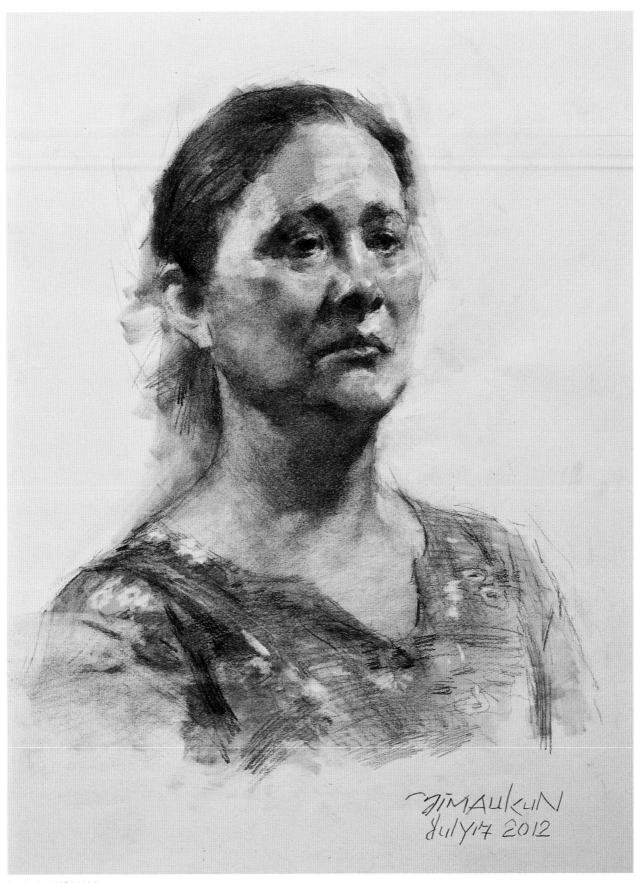

ATAYAL WOMAN
Charcoal pencil on paper, 23¾" × 19½" (60cm × 50cm), 2012

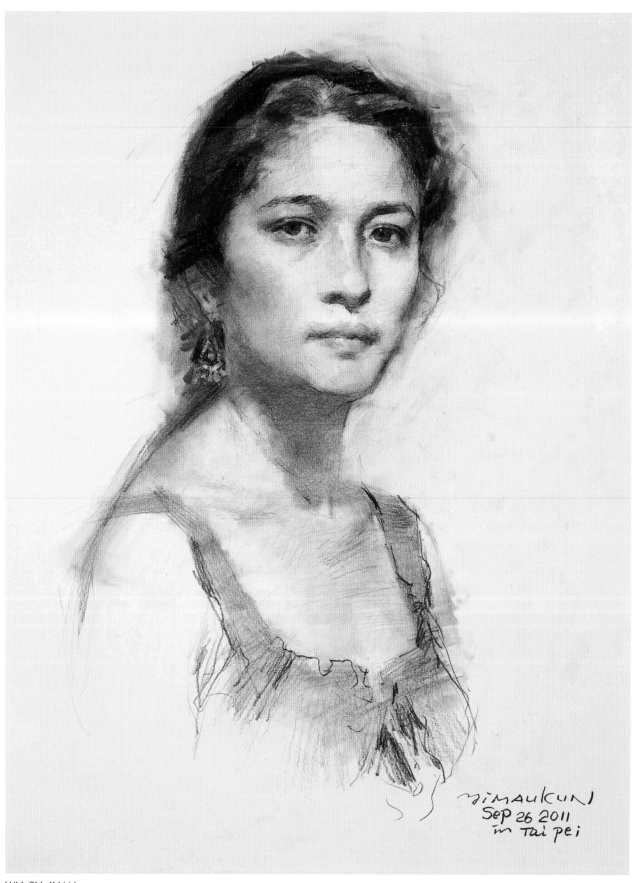

WU SU-JUAN
Charcoal pencil on paper, 25½" × 19½" (65cm × 50cm), 2011

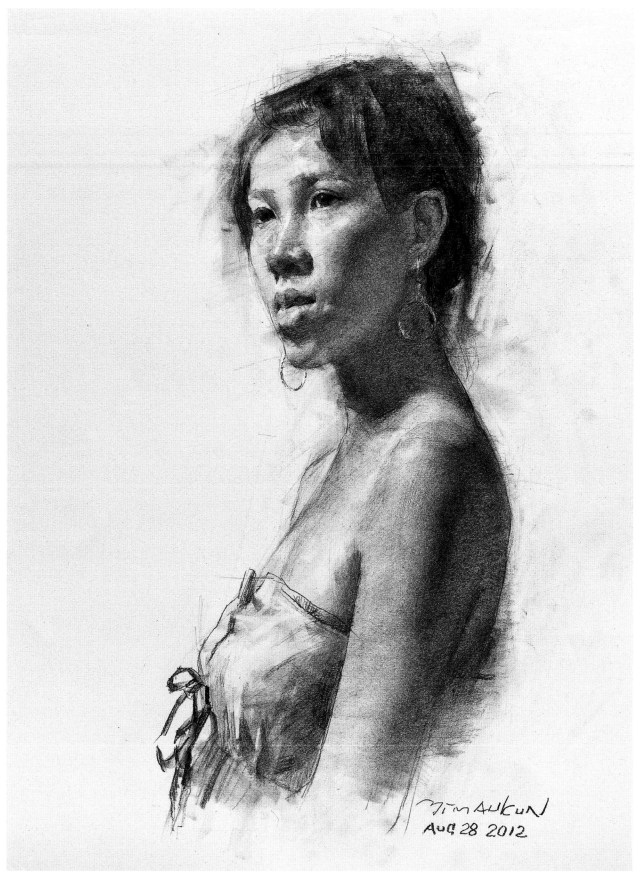

YU QING
Charcoal pencil on paper, 23¾" × 19½" (60cm × 50cm), 2012

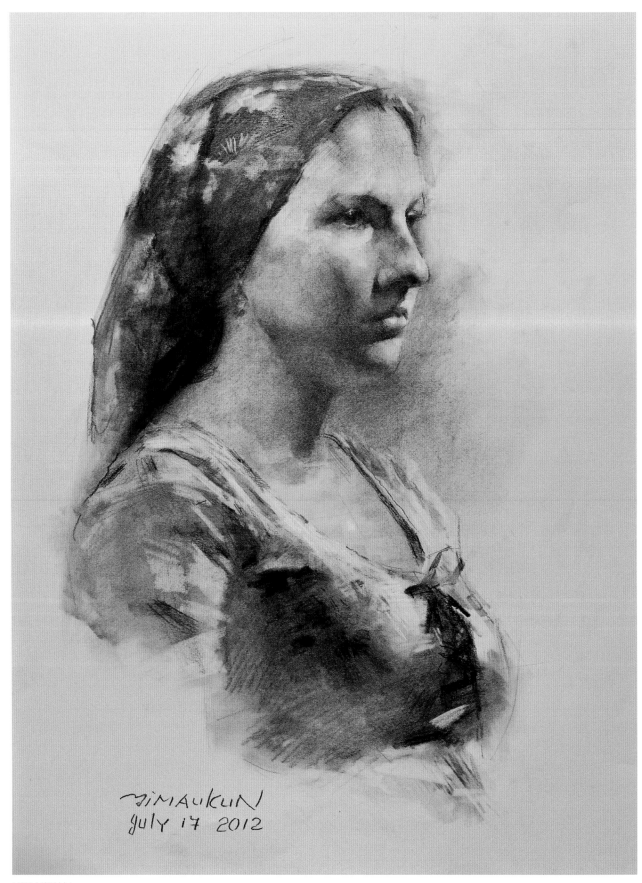

UKRAINIAN
Charcoal pencil on pastel paper, 23¾" × 19½" (60cm × 50cm), 2012

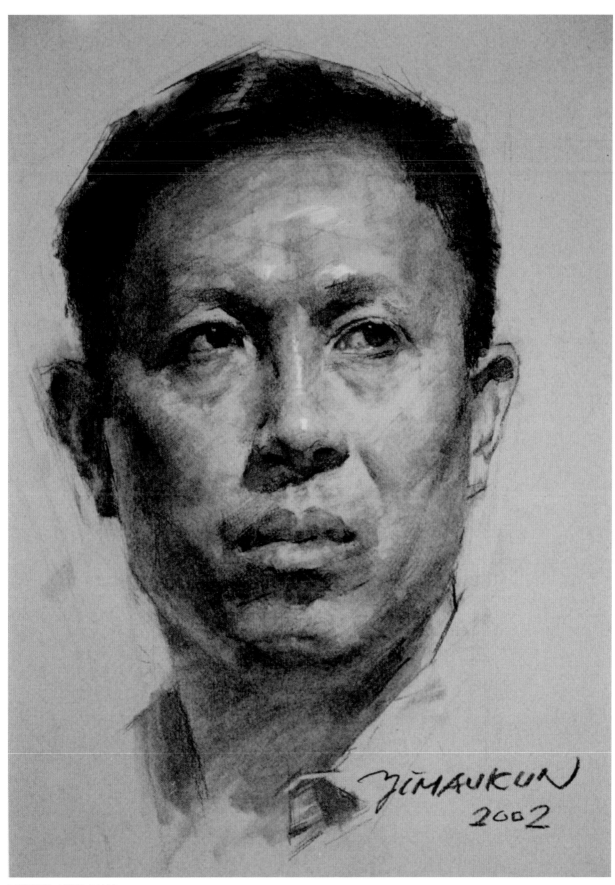

MIDDLE-AGED MAN
Charcoal pencil on paper, 17¾" × 11¾" (45cm × 30cm), 2002

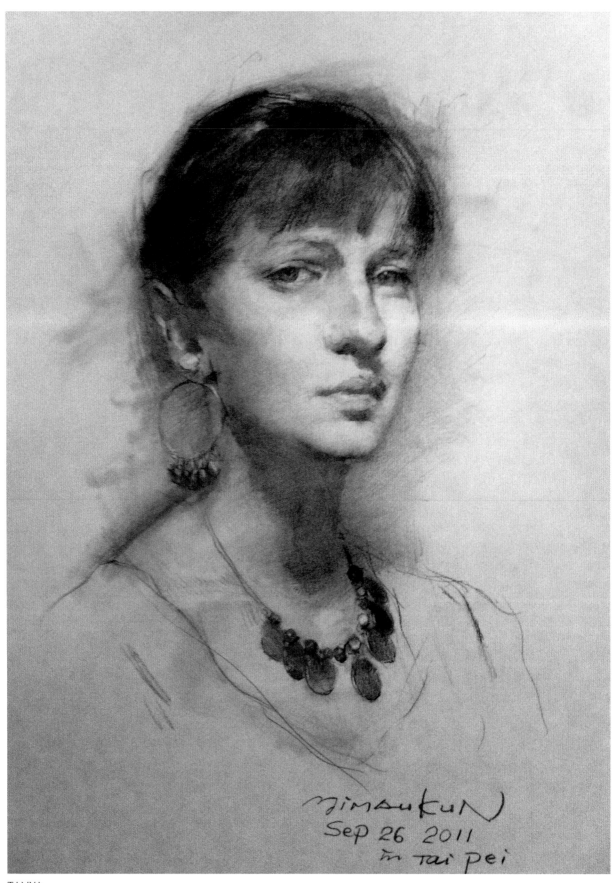

TANYA
Charcoal pencil on paper, 23¾" × 19½" (60cm × 50cm), 2011

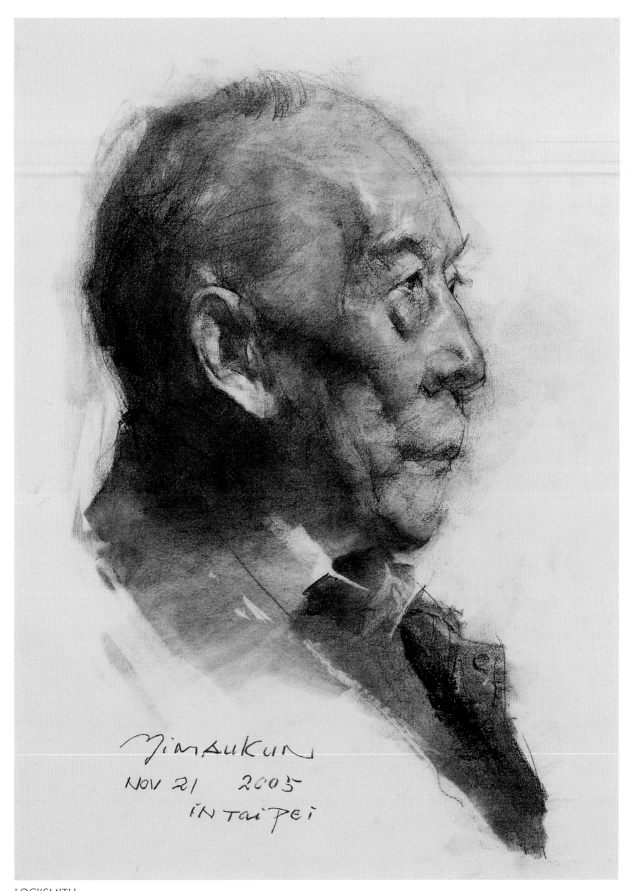

LOCKSMITH
Charcoal pencil on paper, 23¾" × 19½" (60cm × 50cm), 2005

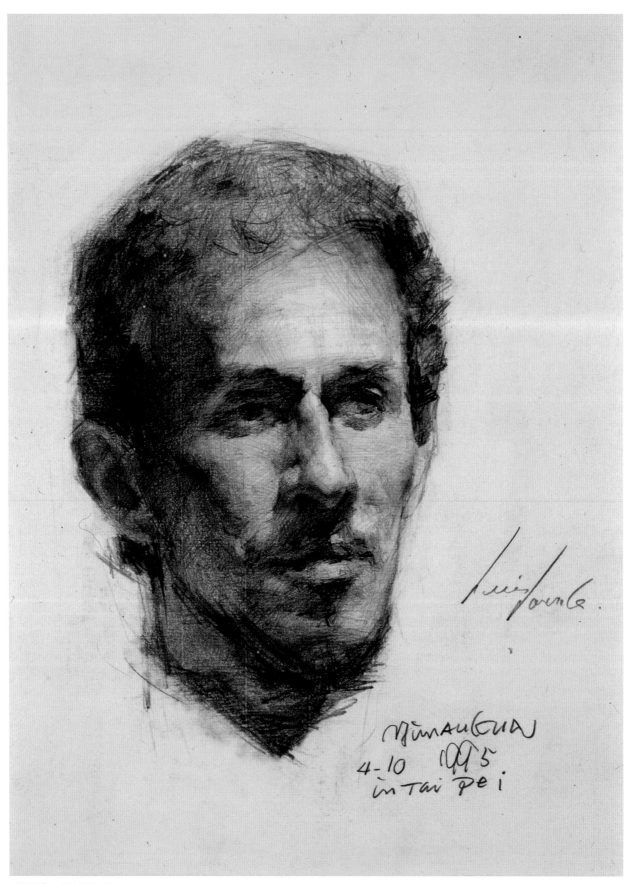

FOREIGN STUDENT
Pencil on paper, 15¾" × 13½" (40cm × 34cm), 1995

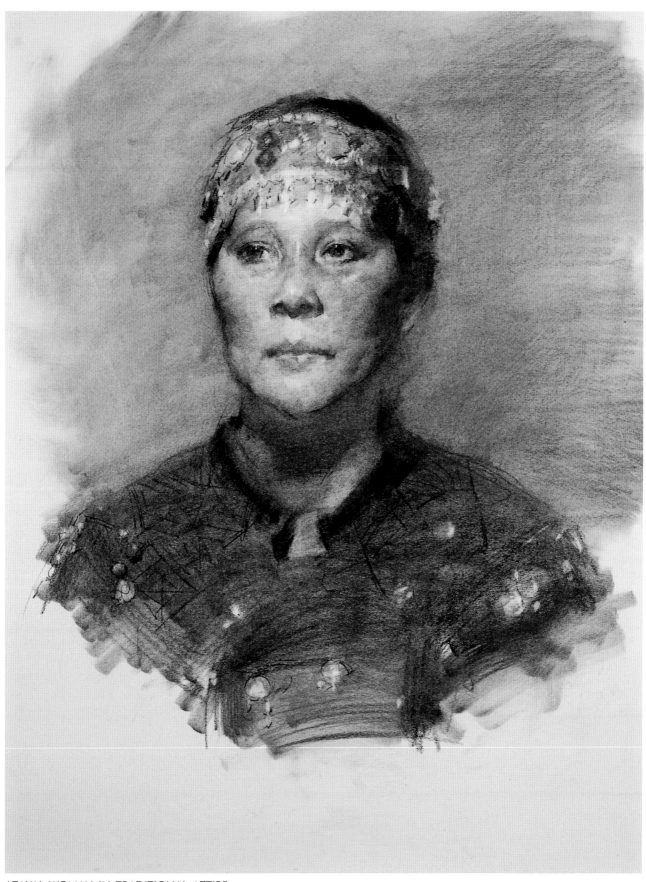

ATAYAL WOMAN IN TRADITIONAL ATTIRE
Pencil on paper, 23¾" × 19½" (60cm × 50cm), 2012

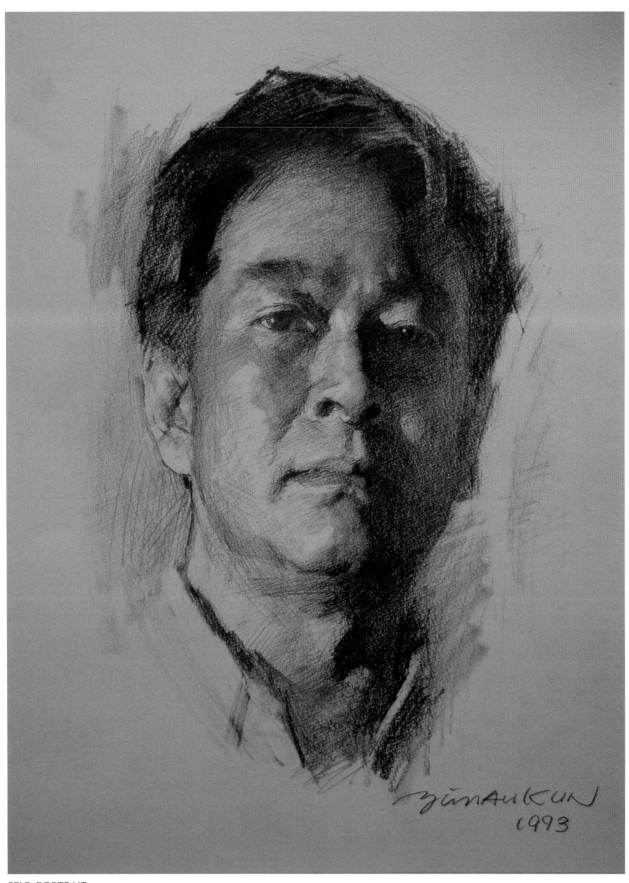

SELF-PORTRAIT
Pencil on paper, 15 × 11¾" (38cm × 30cm), 1993

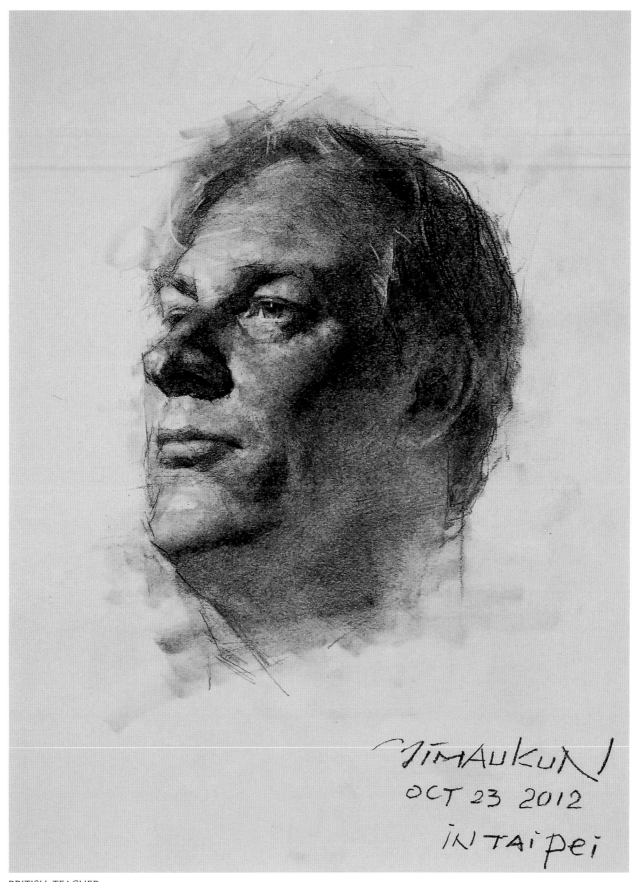

BRITISH TEACHER
Pencil on paper, 23¾" × 19½" (60cm × 50cm), 2012

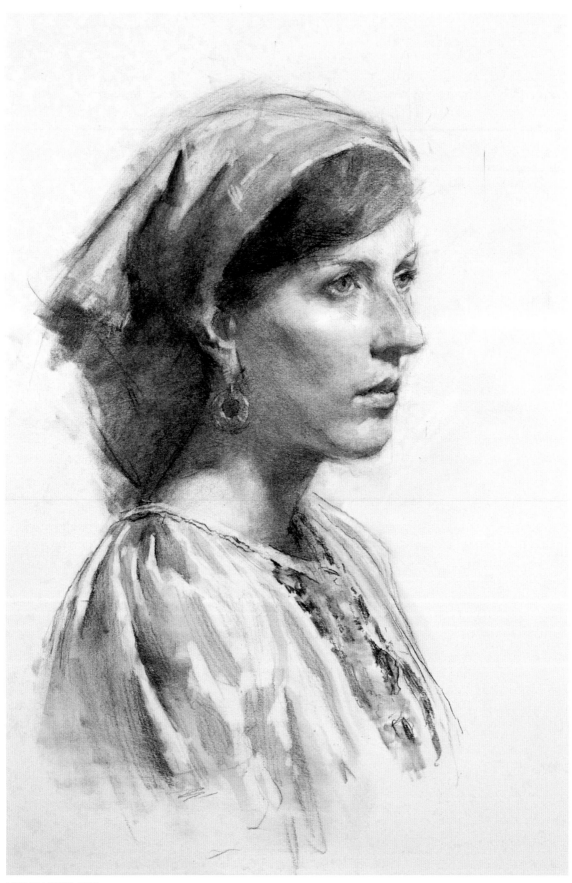

HUNGARIAN GIRL
Pencil on paper, 23¾" × 19½" (60cm × 50cm), 2012

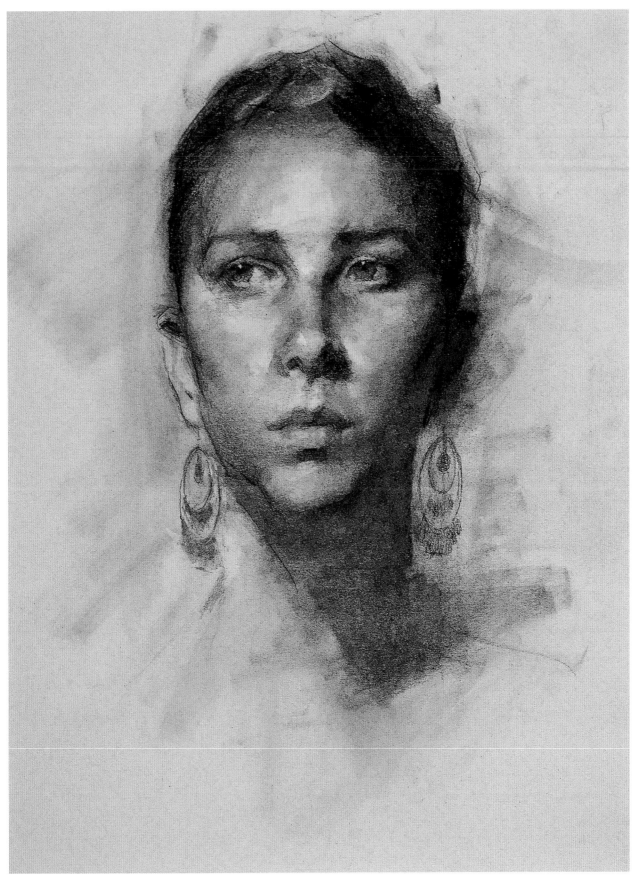

LATINA
Charcoal pencil on paper, 23¾" × 19½" (60cm × 50cm), 2012

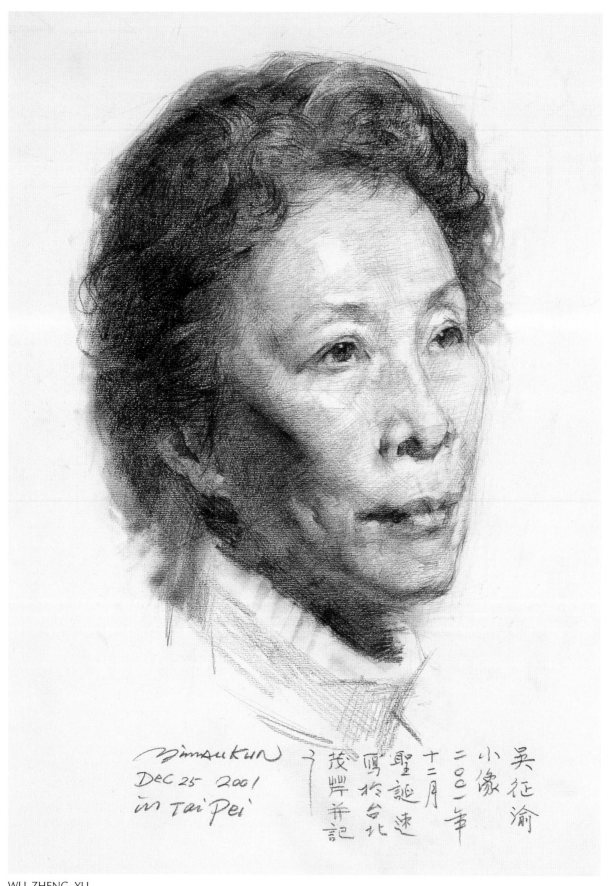

吳征渝

小像

二〇〇一年

十二月

聖誕速

寫於台北

茂坤並記

SIMAUKUN

DEC 25 2001

in Tai Pei

WU ZHENG-YU
Pencil on paper, 17¾" × 11¾" (45cm × 30cm), 2001

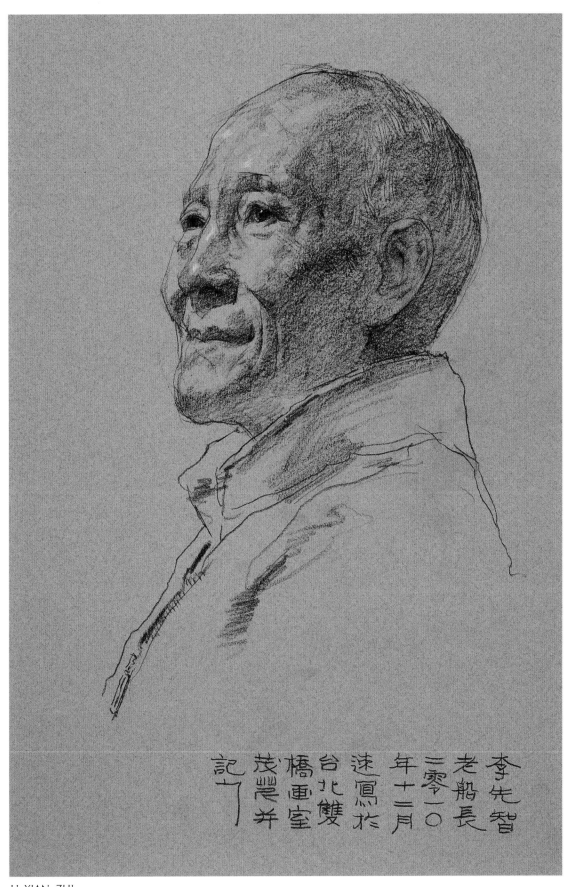

李先智
老船長
二零一〇
年十一月
速寫於
台北雙
橋畫室
茂崇并
記

LI XIAN-ZHI
Pencil on paper, 19¼" × 12½" (49cm × 32cm), 2010

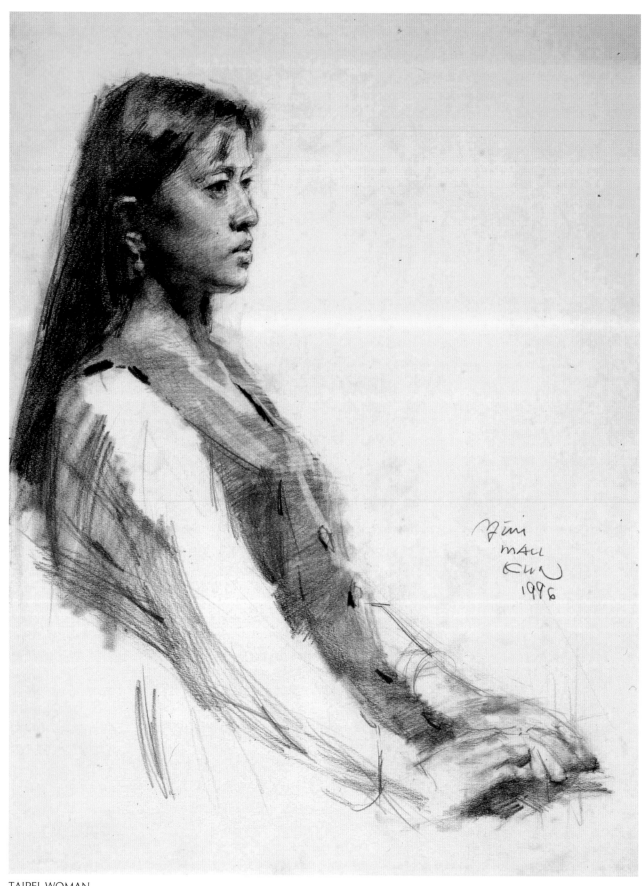

TAIPEI WOMAN
Pencil on paper, 19½" × 17¾" (50cm × 45cm), 1996

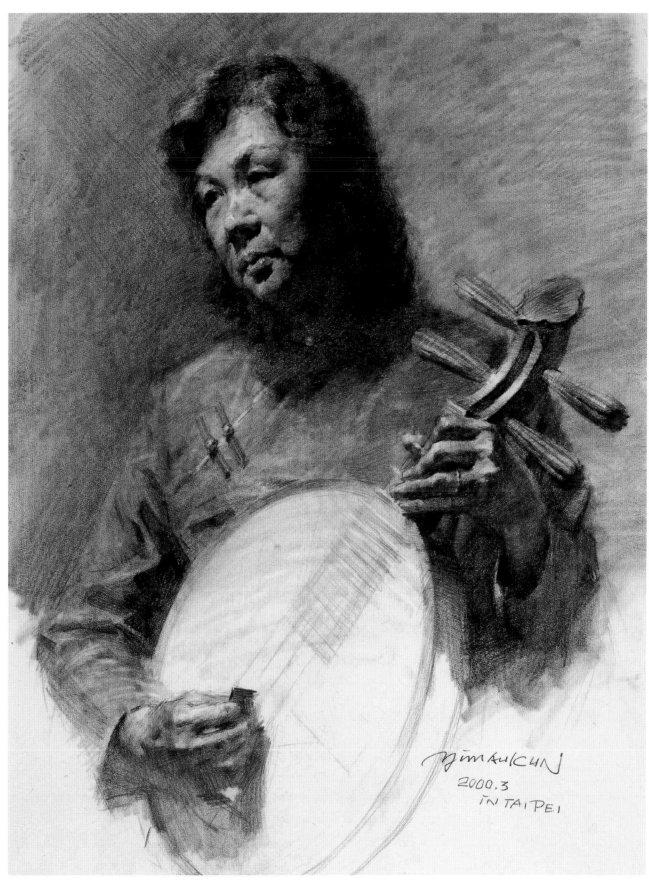

WOMAN WITH STRING INSTRUMENT
Pencil on paper, 25½" × 19½" (65cm × 50cm), 2000

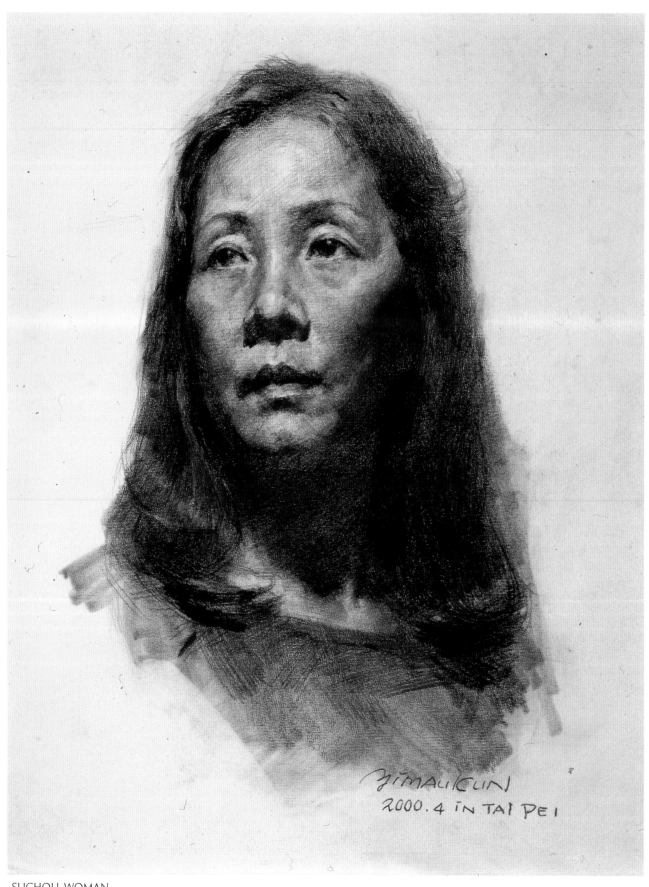

SUCHOU WOMAN
Pencil on paper, 19½" × 13¾" (50cm × 35cm), 2000

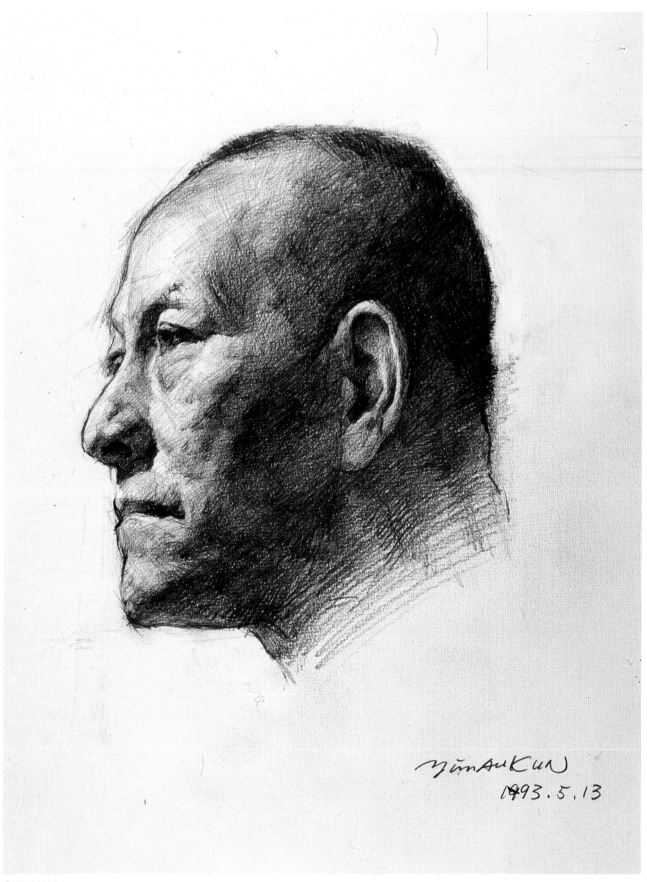

OLD MAN
Pencil on paper, 17¾" × 14½" (45cm × 37cm), 1993

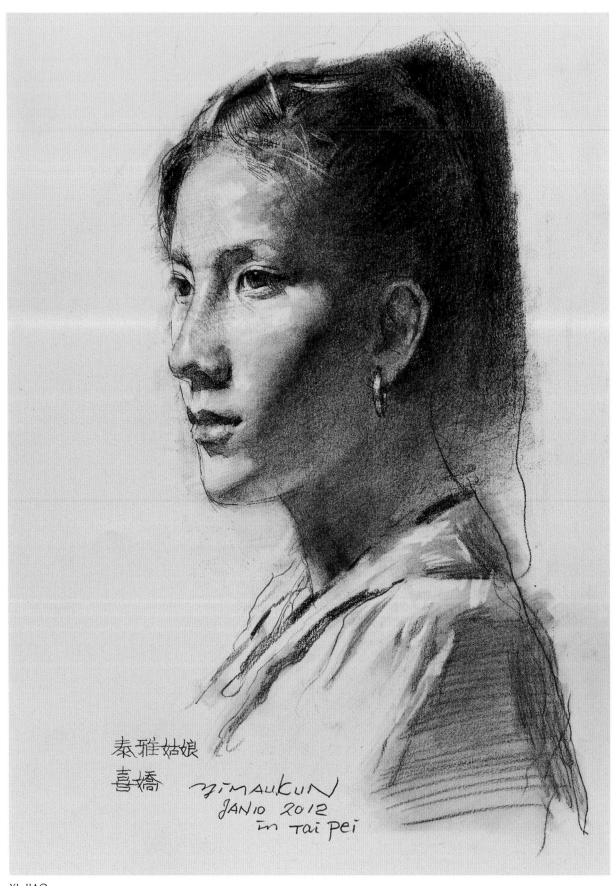

泰雅姑娘

喜嬌

YIMAUKUN
JAN10 2012
in TAI PEI

XI-JIAO
Pencil on paper, 23¾" × 19½" (60cm × 50cm), 2012

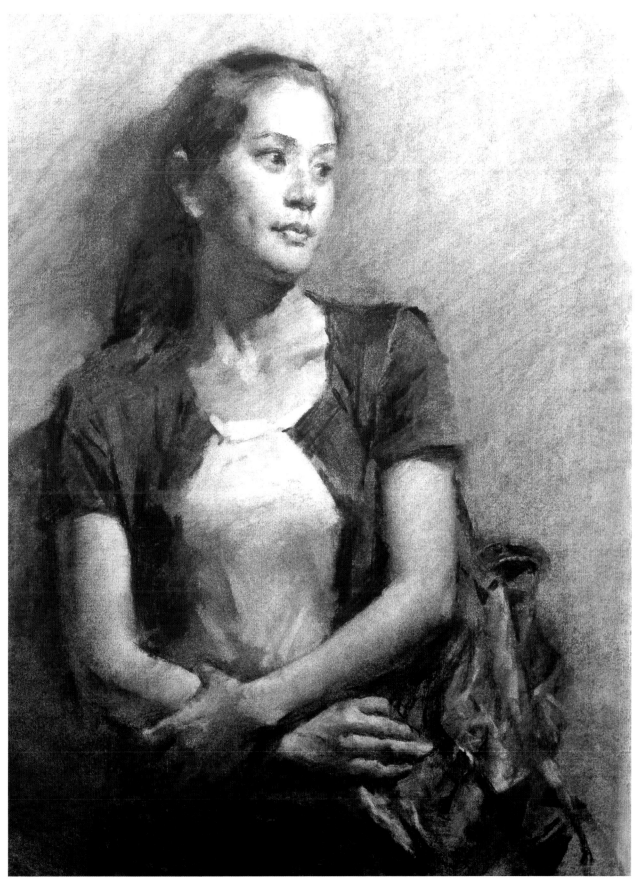

ART STUDENT
Pencil on paper, 30½" × 21½" (79cm × 56cm), 2000

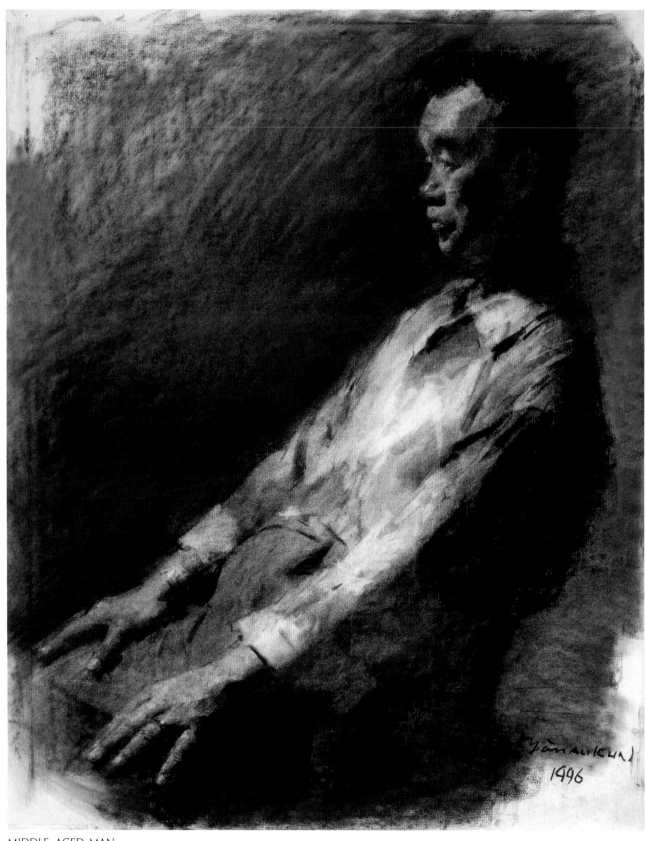

MIDDLE-AGED MAN
Charcoal on paper, 26¾" × 21¾" (68cm × 55cm), 1996

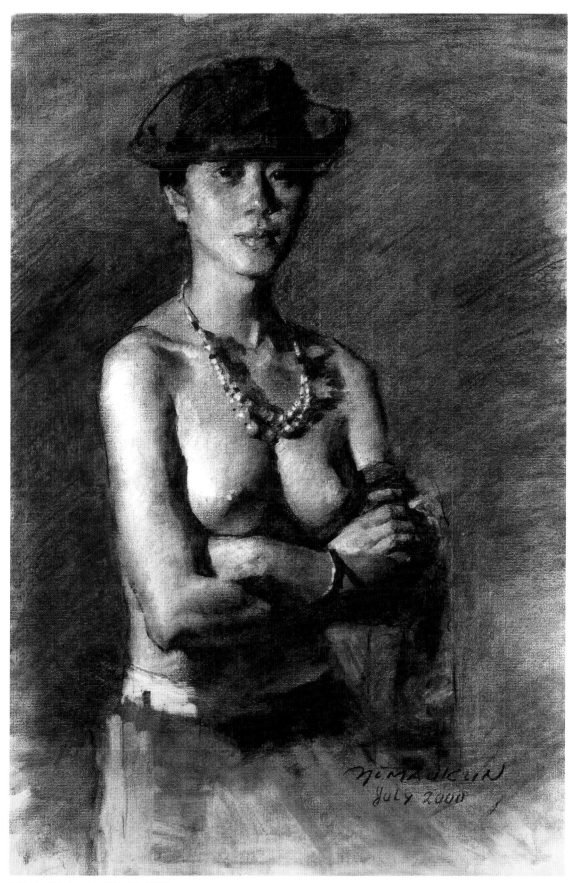

WOMAN WITH COWBOY HAT
Charcoal on paper, 30½" × 21¼" (77cm × 54cm), 2000

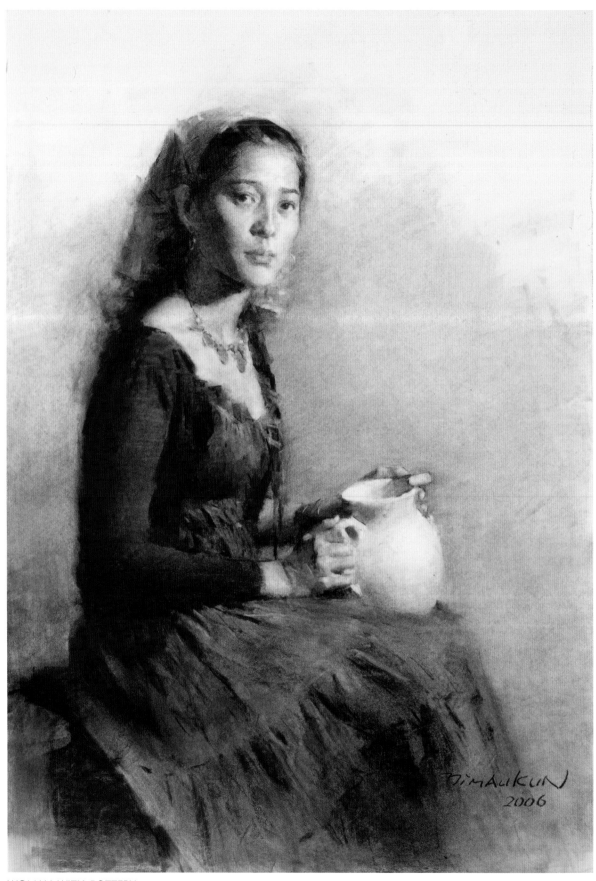

WOMAN WITH POTTERY
Charcoal MBM on paper, 42½" × 29" (108cm × 74cm), 2006

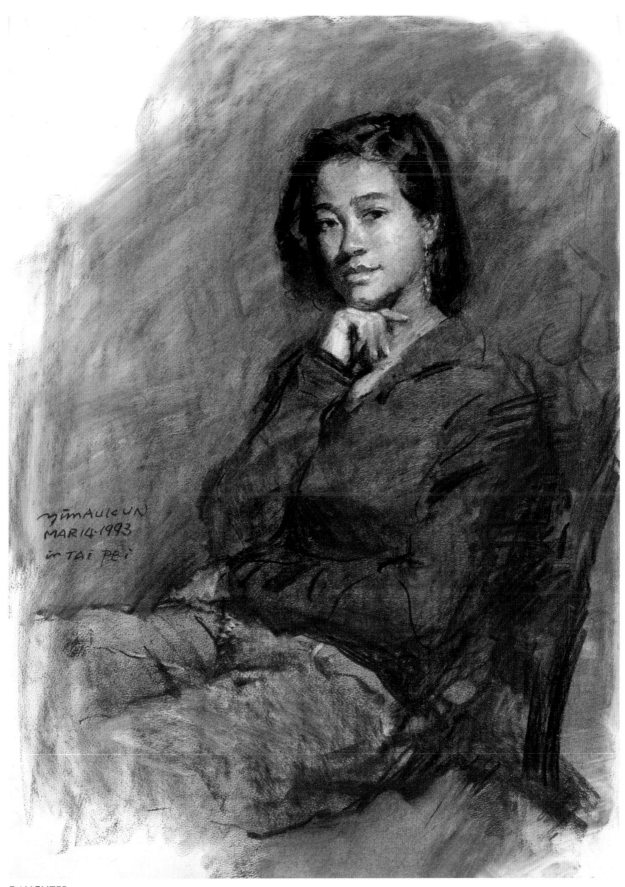

DAUGHTER
Charcoal on paper, 25" × 19" (64cm × 48cm), 1993

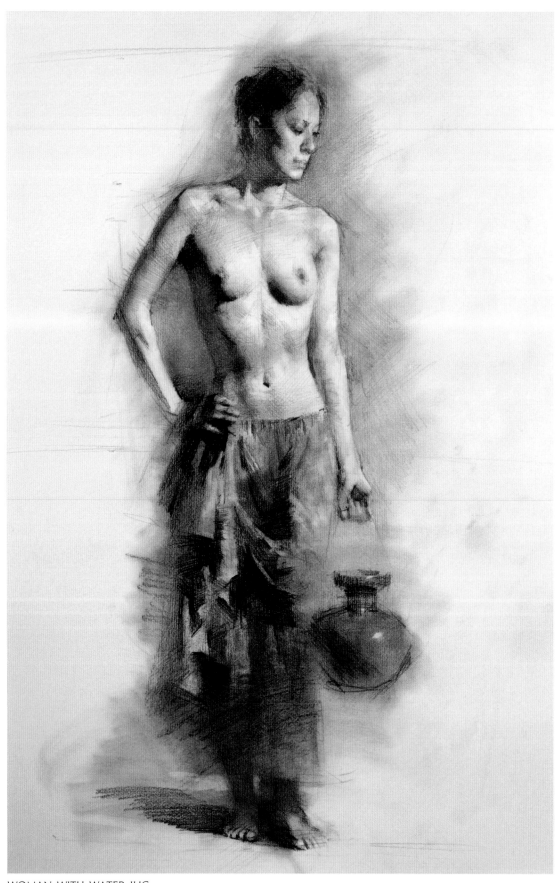

WOMAN WITH WATER JUG
Pencil on paper, 25½" × 19½" (65cm × 50cm), 2004

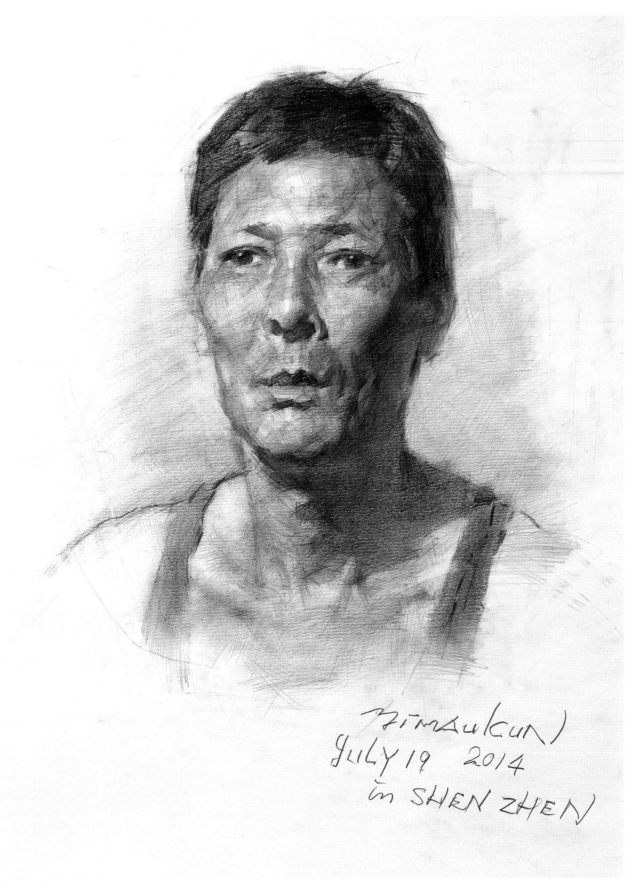

MAN FROM JIANXI
Charcoal on paper, 24" × 20" (61cm × 51cm), 2013

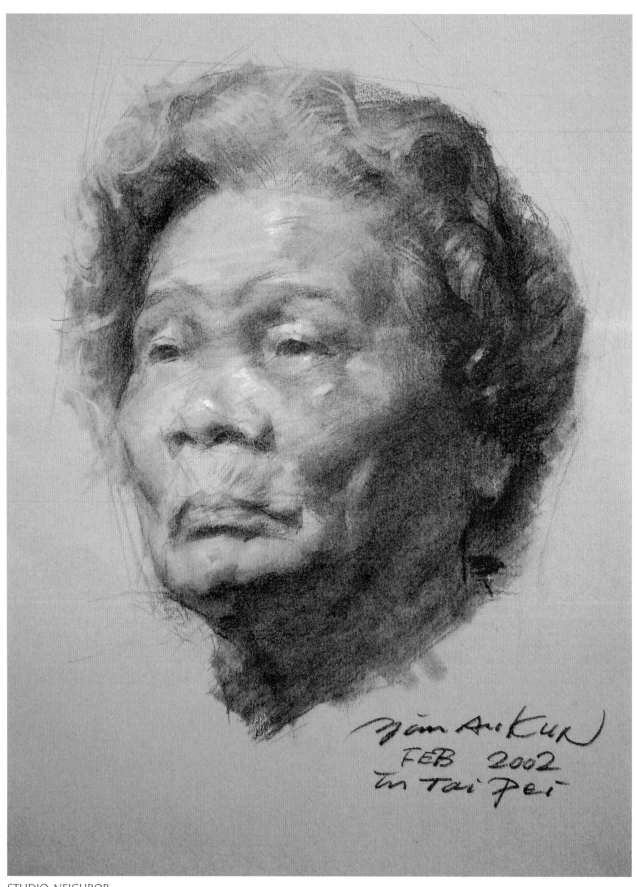

STUDIO NEIGHBOR
Pencil on paper, 25½" × 19½" (65cm × 50cm), 2002

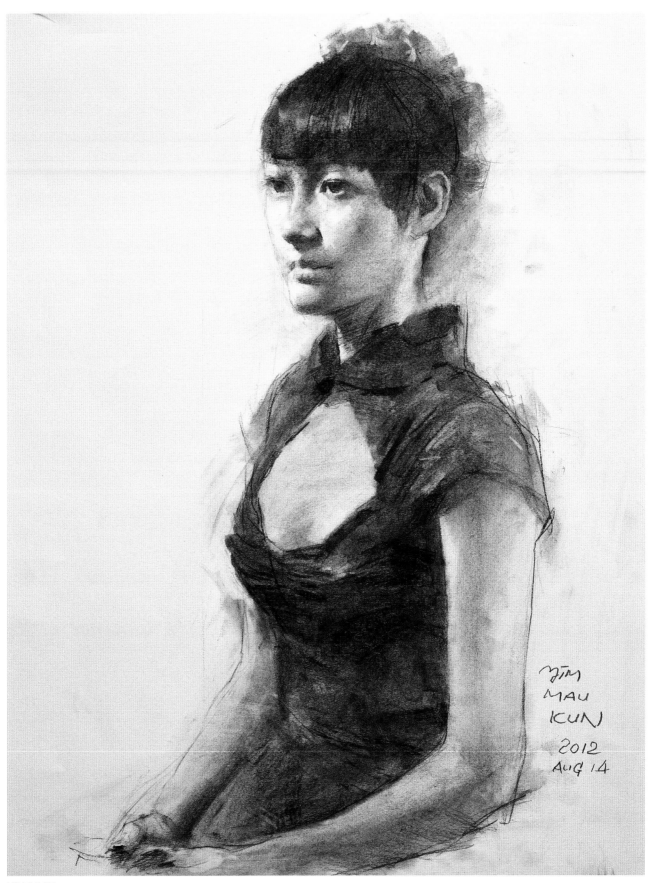

XIUQING
Charcoal on paper, 24" × 20" (61cm × 51cm), 2014

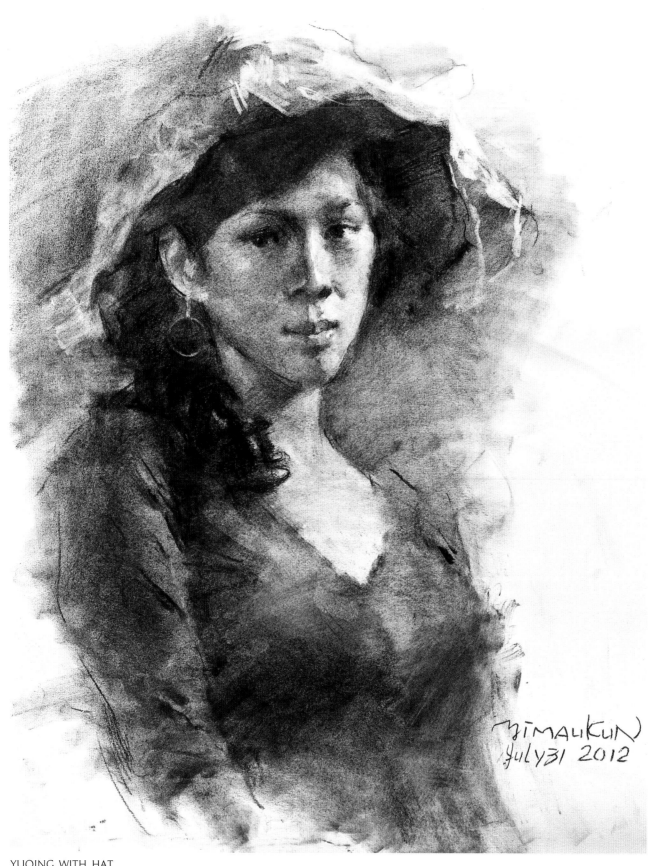

YUQING WITH HAT
Pencil on paper, 25½" × 19½" (65cm × 50cm), 2012

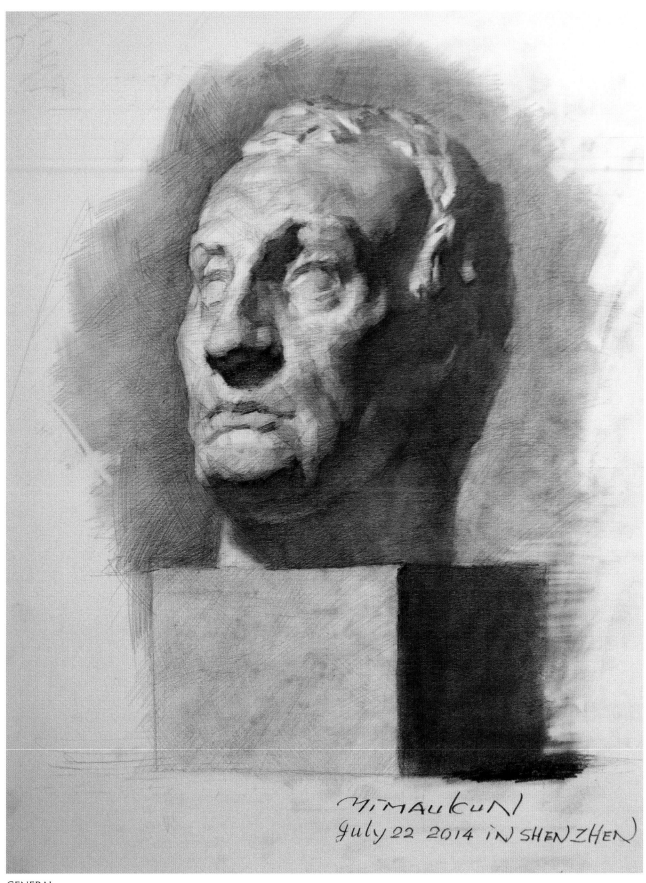

GENERAL
Charcoal on paper, 24" × 20" (61cm × 51cm), 2014

INDEX

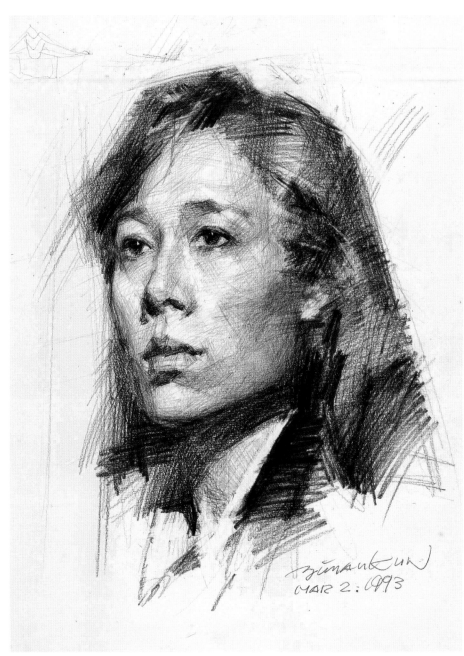

TAIPAI WOMAN
Pencil on paper, 18" × 14½" (46cm × 36cm), 1993

LESSONS IN MASTERFUL PORTRAIT DRAWING. Copyright © 2017 by Mau-Kun Yim and Iris Yim. Manufactured in China. All rights reserved. No part of this book may be reproduced in any form or by any electronic or mechanical means including information storage and retrieval systems without permission in writing from the publisher, except by a reviewer who may quote brief passages in a review. Published by North Light Books, an imprint of F+W Media, 10151 Carver Road, Suite 200, Blue Ash, Ohio, 45242. (800) 289-0963. First Edition.

a content + ecommerce company

ISBN 13: 978-1-4403-4976-8

Other fine North Light Books are available from your favorite bookstore, art supply store or online supplier. Visit our website at fwmedia.com.

21 20 19 18 5 4 3

DISTRIBUTED IN THE U.K. AND EUROPE
BY F&W MEDIA INTERNATIONAL LTD
Pynes Hill Court
Pynes Hill
Rydon Lane
Exeter
EX2 5AZ
United Kingdom
Tel: (+44) 1392 797680

Edited by Christine Doyle and Kristy Conlin
Designed by Clare Finney
Production coordinated by Jennifer Bass

PAGE 2:
SELF PORTRAIT
Pencil on paper, 15" × 12" (38cm × 30cm), 2014

PAGE 5:
YUE-E
Pencil on paper, 19½" × 12½" (50cm × 32cm), 2001

PAGES 16-17
Blueprint icon: Created by Creative Outlet from the Noun Project
Foundation icon: Created by Creative Stall from the Noun Project
Hammer icon: Created by Creative Stall from the Noun Project
Wiring icon: Created by Cor Tiemens from the Noun Project
House icon: Created by Creative Outlet from the Noun Project

METRIC CONVERSION CHART

To convert	to	multiply by
Inches	Centimeters	2.54
Centimeters	Inches	0.4
Feet	Centimeters	30.5
Centimeters	Feet	0.03
Yards	Meters	0.9
Meters	Yards	1.1

ABOUT THE AUTHOR

Born in the Chinese Province of Hunan in 1942, Mau-kun Yim is a graduate of the Guangzhou Academy of Fine Arts. Runner-up in the National Chinese Art Exhibition in 1974, he received first prize in the Guangdong Province Art Exhibition four years later.

His paintings were exhibited at the Simic Gallery in California in 1981, and he had his first solo exhibition in Hong Kong in 1985. His portraits of the Taiwanese Premier Lee Huan and the then Vice President Lee Tung-Hui assured his success. He also has painted numerous portraits for corporate executives, politicians and many other prominent personalities in Taiwan.

In 1989, Mau-kun Yim moved to Taipei, where he continues to focus on narrative paintings inspired by modern Taiwanese as well as ancient Chinese history.

Over the years, he has had many solo exhibitions in the United States, Hong Kong, China and Taiwan. He is the author of nearly 30 books on drawing and oil painting and is frequently invited to speak at universities and art academies.

Mau-kun Yim's works have been featured or reviewed by major Taiwanese dailies including the *United Daily* and the *China Times*. Winner of First Place in the Portrait Society of America's 2005 International Competition, he has held seminars in the U.S. from New York to Arizona to California.

ABOUT THE AUTHOR

Iris Yim is the founder of Sparkle Insights, a market research firm that helps companies better understand and connect with the growing multicultural consumer base in the U.S. She has worked with some of the world's largest brands including InterContinental Hotel Group, Hyatt, Novo Nordisk, Novartis, Wells Fargo, McDonald's and others.

Iris is the research chair of the Asian American Advertising Federation and a co-author of the award winning Asian American Market Report published by Phoenix Marketing International in 2005 and 2009. She is an alumna of the RIVA Training Institute and holds an MBA from the University of Michigan and a master's degree in public relations from the University of Southern California.

In her free time, Iris works with her father Mau-kun Yim to introduce his art and publications to readers and collectors in the U.S. and other areas outside of Greater China. She enjoys being the bridge between artists and art lovers who don't speak Mandarin and her father who doesn't speak English. The way she sees it, it's very similar to her role as a market researcher, being a bridge between clients and consumers.

ACKNOWLEDGEMENTS

This book has come a long way and is the labor of love for many. We would like to thank Marsh Cassady for helping us with the original book proposal, Kitty Lai and Ned Jacob for believing in this book long before it took any tangible shape, Royce Grubic for editing, and North Light editors Mary Bostic and Kristy Conlin for their help in making this book a reality.

IDEAS. INSTRUCTION. INSPIRATION.

Receive FREE downloadable bonus materials when you sign up for our free newsletter at artistsnetwork.com/Newsletter_Thanks.

Find the latest issues of *The Artist's Magazine* on newsstands or visit artistsnetwork.com.

These and other fine North Light products are available at your favorite art & craft retailer, bookstore or online supplier. Visit our websites at artistsnetwork.com and artistsnetwork.tv.

Follow North Light Books for the latest news, free wallpapers, free demos and chances to win FREE BOOKS!

GET YOUR ART IN PRINT!

Visit artistsnetwork.com/splashwatercolor for up-to-date information on Splash and other North Light competitions.